In Stoddard's Footsteps

The Adirondacks
Then & Now

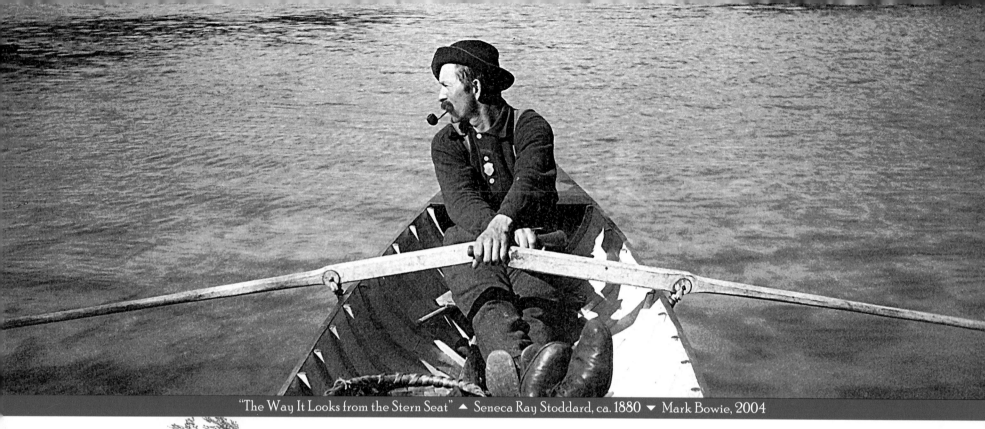

"The Way It Looks from the Stern Seat" ▲ Seneca Ray Stoddard, ca. 1880 ▼ Mark Bowie, 2004

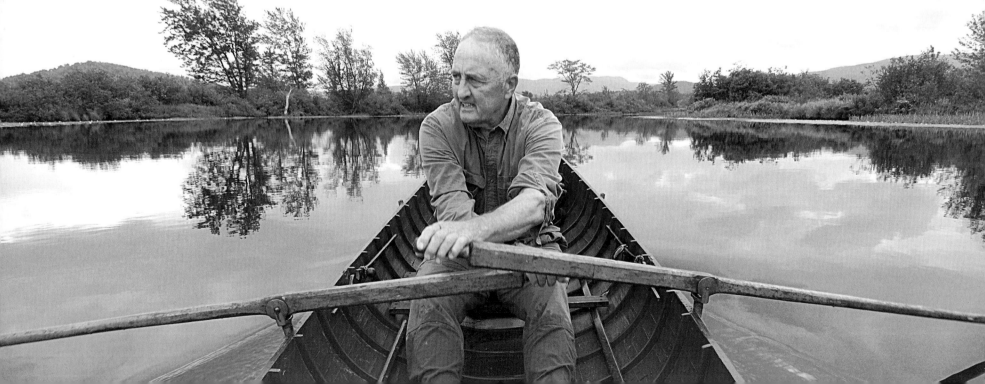

In Stoddard's Footsteps

The Adirondacks Then & Now

Featuring the Photography of **Seneca Ray Stoddard & Mark Bowie**

Text by Mark Bowie & Timothy Weidner

North Country Books, Inc.
Utica, New York

Chapman Historical Museum
Glens Falls, New York

To

Seneca Ray Stoddard ~ Who with skill, ingenuity, and entrepreneurial drive captured and shared the spirit of the Adirondacks

Bill Frenette ~ In fond memory of a consummate woodsman and historian

My grandfather, Richard Dean, photographer ~ In loving memory

Contents

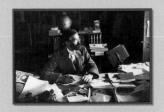
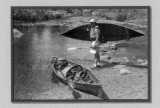
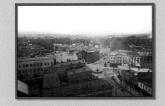
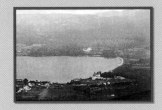

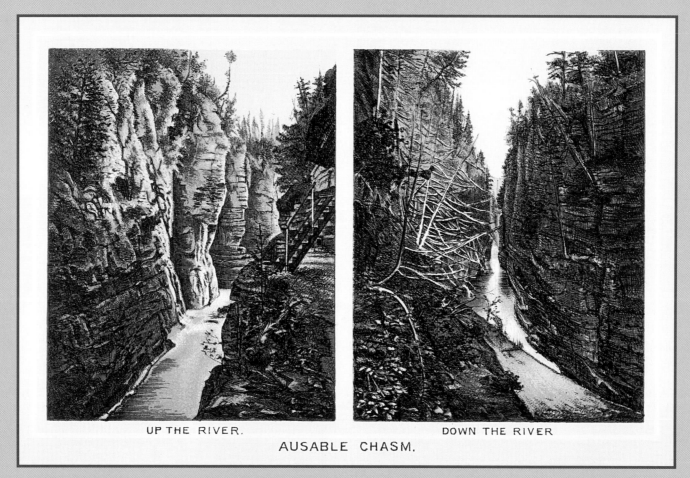

UP THE RIVER. DOWN THE RIVER

AUSABLE CHASM.

Plate 4, lithograph, Ausable Chasm, from *The Adirondacks*, 1878

In a career spanning the settling of the Adirondack wilderness, the heyday of the guide, the steamship, and the grand hotel, Seneca Ray Stoddard produced thousands of images of the evolving landscape. Influenced by the Hudson River School painters and the luminists' creative use of natural light, he photographed forests reflected in silky lakes, lumberjacks wielding axes, new communities sprouting from the woods, and tourists in Victorian regalia arriving by train and stage.

Stoddard was an unabashed Adirondack promoter, as prolific with pen as with camera. From his Glens Falls studio, he and his assistants published photographic prints and stereographs, books, brochures, train schedules, newsletters, and maps—the largest documentary record of late-nineteenth-century life in the region.

Seneca Ray Stoddard | Photographer, 1843–1917

From the perspective of today, it is easy to look at Seneca Ray Stoddard's nineteenth century images as a record of the unspoiled Adirondacks—an era when the region was first explored and experienced by only a few. However, to be accurate and informative, an examination of his photographs must take into account his motivations and the cultural climate in which he worked.

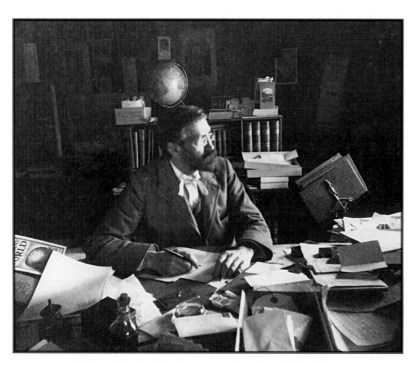

Seneca Ray Stoddard writing in his Glens Falls office

Born May 13, 1843, Seneca Ray spent his childhood in rural villages in northern New York—at first in Wilton, a Saratoga County community within sight of the Adirondack foothills, and later in Burke, Franklin County, on the northern edge of the mountains. Little is known of his youth, other than that the family moved often and that he attended school, at least on a part-time basis. It can be assumed that he trained in one of the trades that typified village life, but which is uncertain.

Seeking economic opportunity, Stoddard's family moved again, this time to Green Island, near Troy, New York, where, in 1862, Seneca Ray found employment as an ornamental painter at the Gilbert Car Company. Starting as an apprentice, Stoddard painted landscapes and other popular scenes on the interiors of passenger cars for two years, before he relocated to Glens Falls and went into the sign and ornamental painting business for himself.

Perhaps Stoddard recognized the limited future of his painting trade for he quickly acquired the skills and knowledge required to do wet-plate photography, most likely from the already established Glens Falls photographer, George Conkey. Stoddard was not alone in seeing photography as a potential source of income in the 1860s; he joined many other individuals who purchased the necessary equipment and chemicals and set up their studios in cities and towns across America.

What set Stoddard apart when he opened his photography business in 1867 was that he chose not to open a portrait studio; rather, he

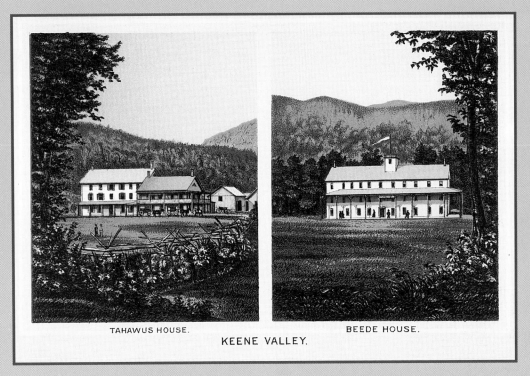

TAHAWUS HOUSE.　　BEEDE HOUSE.

KEENE VALLEY.

Plate 8, lithograph, Keene Valley, from *The Adirondacks*, 1878

opted to concentrate his photography on landscapes. One could conjecture that this choice reflected his artistic training and self-identity, but he also saw it as a market opportunity. His first views were of Glens Falls—both the waterfalls on the Hudson River and such community landmarks as banks, churches, and the homes of prominent citizens. He quickly added views of nearby Lake George and Lake Luzerne and, following an 1873 trip through the Adirondacks, images of Indian Pass, Henderson Lake, Long Lake, and the Raquette River.

By the late 1860s, Glens Falls had become a major departure point for tourists headed for Lake George and other locations in the Adirondack region. Stoddard realized not only that these tourists were looking for mementos of their travels, but also that there was a need for materials that promoted the attractions of the region. On subsequent trips, he canvassed the Adirondacks, photographing the natural wonders and the places where tourists could stay. He also gathered stories about unique Adirondack characters and information about accommodations, lodging rates, and guide services, which he compiled in a guide for tourists, *The Adirondacks Illustrated*, first published in 1874.

During the 1870s and 1880s, Seneca Ray Stoddard took thousands of photographs of the Adirondacks, including several hundred of Lake George. In addition to *The Adirondacks Illustrated*, which he updated annually well into the twentieth century, he also published a

guide to Lake George and numerous other books of his photographs, as well as maps of Lake George, Lake Champlain, and the Adirondacks. Ever the businessman, Stoddard was concerned primarily with creating products that would sell to tourists. In these he promoted the region's natural wonders and historic sites, recreational opportunities, and the qualities of the lodging establishments.

Stoddard's livelihood, to a certain extent, depended on the expansion of railroad routes and the development of new hotels, for they would bring even more tourists to the region. In 1890, he wrote that his guidebook "represents an erratic course that covers substantially the most interesting and diverse interior portions of the great wilderness, noting such changes by the way as time and improved facilities for transportation have brought about..." He often returned to specific locations to photograph newer and grander structures, and he made sure to update his guidebooks with descriptions of their technological improvements.

Although certainly not a reactionary, Stoddard, like many other Americans, probably felt some ambivalence about the impact of the industrial growth that defined the second half of the nineteenth century. It is interesting to note that he photographed both the natural features of the falls on the Hudson and the factories that surrounded them. Among his photographs of mountain and lake vistas one also finds images of bridges, locomotives, and steamboats.

However, over time Stoddard came to realize that some forms of development, if left unchecked, were harmful to the Adirondacks, and he became a fervent advocate for the creation of the Adirondack Park. In the "Greeting" to his 1890 edition of *The Adirondacks Illustrated*, he argued for regulation of the region. Concerned about the effect of uncontrolled timber harvesting on the land and water supplies, he stated that the preservation of the forests was "a question of vital importance not only to the Adirondack region itself but to the State and country as well."

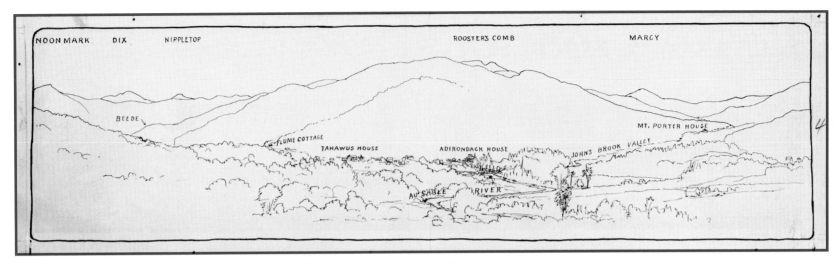

NOON MARK DIX NIPPLETOP ROOSTERS COMB MARCY

BEEDE

MT. PORTER HOUSE

FLUME COTTAGE

TAHAWUS HOUSE ADIRONDACK HOUSE JOHNS BROOK VALLEY

AU SABLE RIVER

Pen & ink sketch, Keene Valley, S.R. Stoddard, ca. 1890

Although concerned about what he perceived to be the abuses of the timber industry, Stoddard recognized that many different parties had legitimate interests in the Adirondacks. In addition to the State of New York, there were game clubs, private landowners, people interested in using the area for recreation, and communities downstream that depended on the Hudson for water. Stoddard argued that a commission, free from influence, was necessary to manage these competing interests.

What Stoddard would have thought about the changes that occurred in the Adirondacks in the decades following his death is purely speculation, but offers food for thought. He might have noted the loss of many old hotels and related businesses in the early twentieth century as tourists turned to new resort areas in America. After World War II he probably would have welcomed the return of the automobile, as new attractions sprang up in the Adirondacks to meet the needs of vacationing Americans. Undoubtedly, Stoddard would have noted the impact of the Adirondack Park Agency and the expansion of state landholdings within the park.

Perhaps he would have traveled through the region once again to photograph the notable landmarks and new points of interest. Foremost an artist and a businessman, Stoddard also saw himself as a chronicler of the Adirondacks, as he put it, "contrasting the old and the new in the procession of changeful years."

Timothy P. Weidner
Executive Director
Chapman Historical Museum

A graduate of the Cooperstown Graduate Program in History Museum Studies, Timothy Weidner has created and contributed to numerous exhibitions and publications that featured the work of Stoddard and other nineteenth century photographers. Tim resides with his wife, Karen, and their family in Glens Falls, New York.

The Re-creations | 2000 - 2007

More than a century after Seneca Ray Stoddard focused his cameras on the region, I endeavored to stand where he stood and rephotograph, as faithfully as I could, the locations of many of his classic images. Working as the gilded Victorian age overlapped the settling of the Adirondack wilderness, Stoddard was a pioneer, the first to record on glass plates and in print a comprehensive view of the area's landscapes and grand hotels, cityscapes, homesteads, industry, and architecture. He also captured stirring portraits of children, settlers, and the vacationing upper class. I photographed his sites between 2000 and 2007. Comparing my re-creations to his originals would reveal how the landscape and its people have changed in the intervening one hundred to one hundred twenty-five years.

My task was daunting. I would first have to ascertain where he took his photographs then determine if it was still possible to physically get there. And I wondered whether my comparisons could fill gaps of time and provide meaningful insights into the journey of history. Would I find the scenic beauty he saw, or had buildings, roads, signage—the necessities and the trappings of twenty-first century living—obliterated his views? How had the Adirondack Park and Forest Preserve, established well into Stoddard's career, reshaped the landscape he photographed to that we see today? And what would the comparisons reveal about the people, their work and leisure activities, their aspirations and changing values?

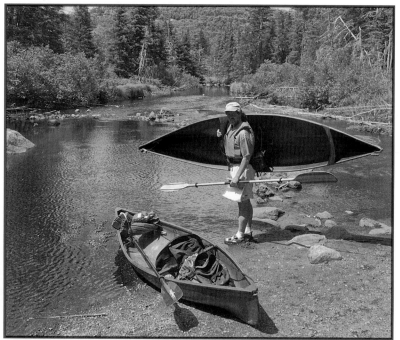

Photograph by Mike Prescott

Mark Bowie at the Marion River to rephotograph a Stoddard scene

I immersed myself in thousands of photographic prints, stereographs, original glass plate negatives, sketches, line drawings, paintings, guidebooks, maps, calendars, train schedules, dining hall menus, and lantern slide show notes—a treasure trove of Seneca Ray's originals—in the archives of the Chapman Museum in Glens Falls, New York. I made copies of the images I hoped to reshoot—reflecting Stoddard's variety of subjects across the Adirondacks—and headed for the field.

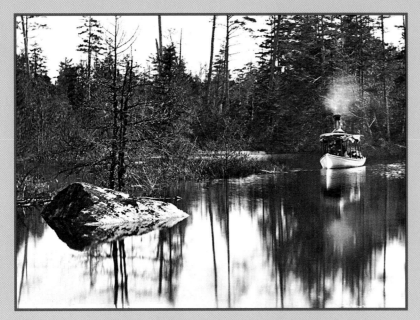

Steamboat on the Marion River, ca. 1880

Canoe on the Marion River, 2007

To "replicate" scenes, I carefully aligned visual clues in Stoddard's images with present-day structures: mountains, rock outcrops, trees, shorelines, islands, buildings, roads—until I honed in on Stoddard's position and angle of view. Finding well-known landmarks or sites along long-established routes often proved relatively easy. Other locations, where few, if any, noteworthy features in Stoddard's photos remained, required more detective work. But the hunt was exciting. And when I eventually deciphered his vantage point, often a light of realization would dawn and I'd stand transfixed. The great photographer had stood on this very spot long ago, and what he saw moved him enough to make an image. I felt close to him then, as if I were his time-traveling assistant, here to record a scene he could no longer photograph himself.

I have visited the locations of over one hundred fifty Stoddard images. The differences between what we captured run the gamut from subtle to drastic. Some views appeared as I expected; others were complete surprises. Some were demoralizing, a healthy number startlingly pleasant. Each was illuminating. The most compelling—for subject and historical perspective—are presented here.

Geologically stable landforms remain much as Stoddard saw them. But, in places, man-made structures and vegetation have undergone sweeping changes, making his views trickier to locate. In Stoddard's day, forests were routinely clear-cut around a new village, the timber used for buildings. Where he climbed nearby hillsides for unobstructed overviews, I was frequently stymied by tree growth. The barren hillside from which he photographed Upper Jay, for instance, had become state land shortly after; it's now covered with one hundred-year-old forest. It was physically impossible for me to re-create his view. To the contrary, elsewhere, one hundred years of development has overwhelmed once-scenic vistas.

Like Stoddard, I used a mechanical, large format view camera and black-and-white negatives—initially. The aspect ratio of my 4" x 5" images didn't match Stoddard's formats—he most often shot negatives measuring about 4" x 7", 6.5" x 8", and 6" x 10"—but they rendered scenes with statuesque perspective. Architectural lines could be rendered straight, minimizing lens distortion. And photographing with the big camera, under a dark cloth, closely replicated Stoddard's field technique. Later, however, to better simulate the dimensions of Stoddard's negatives and to highlight the incredible technological advancements that have swept the photographic medium since his era, I shot with 35mm cameras, first with black-and-white film, then with color. Digitally scanning and converting the color image to black and white helped retain subtle tonal variations. Later still, I recorded images without using film or glass plates (something Stoddard couldn't have fathomed!); I recorded them on electronic sensors, in color, with digital-SLR cameras. I later converted them to black and white digitally.

Any differences in angle of view or perspective between our images are due not only to how well I ascertained and matched Stoddard's position, but also to differences in our film formats and the focal lengths of our lenses. The high resolution of my film and digital captures gave me the flexibility to crop or enlarge them, if needed, to best correspond with Stoddard's view.

On site of my very first re-creation—Prospect Point on Blue Mountain Lake—I determined Stoddard's position and set up my camera. Under the dark cloth, I instinctively began composing the scene to fit my eye, until I recalled that this project was about rephotographing scenes from Stoddard's viewpoint, in his style. The new image would not solely be my creation, but a reincarnation of his. My purpose was to present the landscape through time, regardless of the "scenic value" of my image. If that meant photographing rather uninspired vacation cabins where Stoddard had captured a grandiose hotel, then against my creative grain, I did. The comparison could speak for itself.

Viewed side-by-side, Stoddard's original photographs and my re-creations open a portal on Adirondack history. Like good writing, they can be read between the lines. You can interpolate the courses of industry, of tourism, architecture, fashion, and the continued settling of the Adirondack wilderness over the last century. Each set is a visual puzzle, compelling us to search for the similarities and differences between them and to fill the gaps along the historical path between Stoddard's Victorian era and our contemporary times. Some only whisper hints; others give definitive accounts. Each brings us face-to-face with living history.

Mark Bowie

Mark Bowie, the grandson of legendary Adirondack photographer Richard Dean, is one of the premiere photographers and writers working in the Adirondacks today. His first book, Adirondack Waters: Spirit of the Mountains, *published by North Country Books, won the Adirondack Center for Writing award for Photography Book of the Year in 2007. His work has been published in magazines and books, on calendars and posters, and in advertising media. He is a sought-after speaker and his multimedia shows on the Adirondacks have educated and entertained audiences across the region. He resides with his wife, Rushelle, in Pittsfield, Massachusetts.*

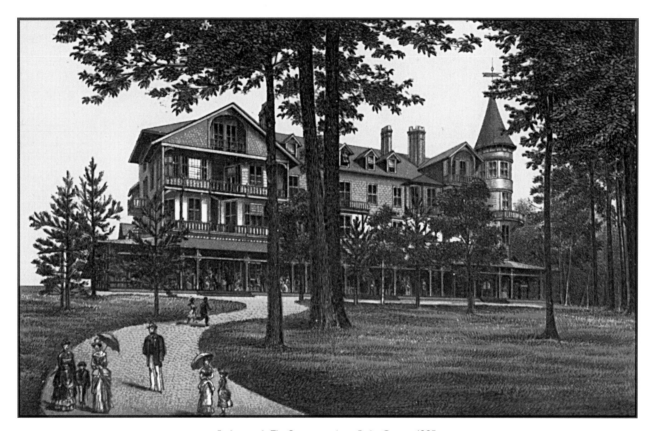

Lithograph, The Sagamore, from *Lake George*, 1885

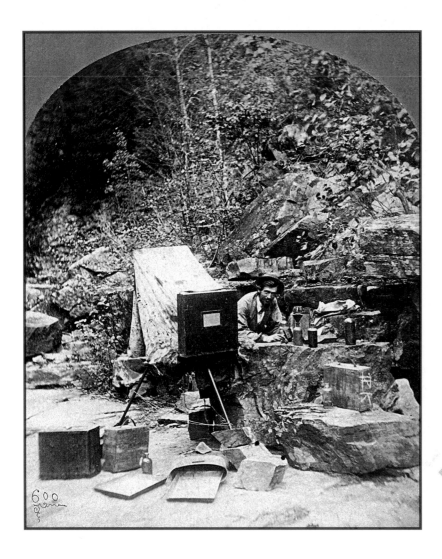

Seneca Ray Stoddard exposed his large-format images on glass plates that were about one-quarter inch thick and very fragile. He had to painstakingly haul them into the wilds on horseback and stagecoaches, in boats and trains. Their welfare—whether they would survive the rigors of a backwoods hike or the wagon ride back to the studio—must have been a constant concern.

Early in his career, Stoddard had to coat glass plates with photographic emulsion, expose the plates, and process them before they dried (in about two minutes). The advent of dry plates in 1879–80 allowed outdoor photographers like Stoddard to return to their studios to process their work, eliminating the need to lug a portable darkroom and processing chemicals into the field. Around 1890, Seneca Ray began using the new flexible negatives invented by George Eastman.

Stoddard was a highly skilled printmaker. He used different papers and toners for artistic effect. Albumen (egg white)-coated paper gave his prints remarkable depth with a lustrous sheen. He also coated them with gold chloride, giving them a warm, reddish-brown tone.

◀ STODDARD WITH HIS
PORTABLE DARKROOM
Ausable Chasm
ca. 1875

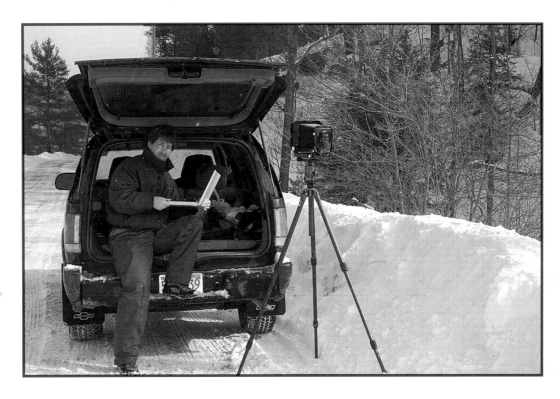

MARK BOWIE ▶
SELF-PORTRAIT
2005

Today outdoor photographers can travel quickly and comfortably on paved roads, hauling as much equipment as their motorized vehicles can hold. Waterproof and wind-resistant clothing helps keep shooters warm and dry, extending the time they can work comfortably in the field. Networks of marked hiking trails lead to many of the Adirondacks' most scenic mountaintop vistas. Powerboats and lightweight canoes and kayaks give photographers unprecedented access to the region's abundant waters.

Technological advances in photographic equipment since Stoddard's day—acetate-backed film, color film, filters, flash units, ultralight tripods, interchangeable lenses from extreme wide-angle to telephoto, and a wide array of cameras—continue to refine the art of picture-taking. Today's electronic cameras are miniature computers, with automatic winding, exposure, and focusing modes. They are so compact, easy to use, and affordable that most families own at least one.

Digital imaging is literally redefining how photographers record an image. With digital cameras, I can review my images while still in the field, to refine my compositions and ensure proper exposure. As Stoddard did, I carry a portable darkroom in the field; mine is a laptop computer loaded with image-processing software with which I can optimize images for contrast and color with greater precision than ever before.

Photogravure, cover of *Glens Falls Illustrated*, 1889

Glens Falls

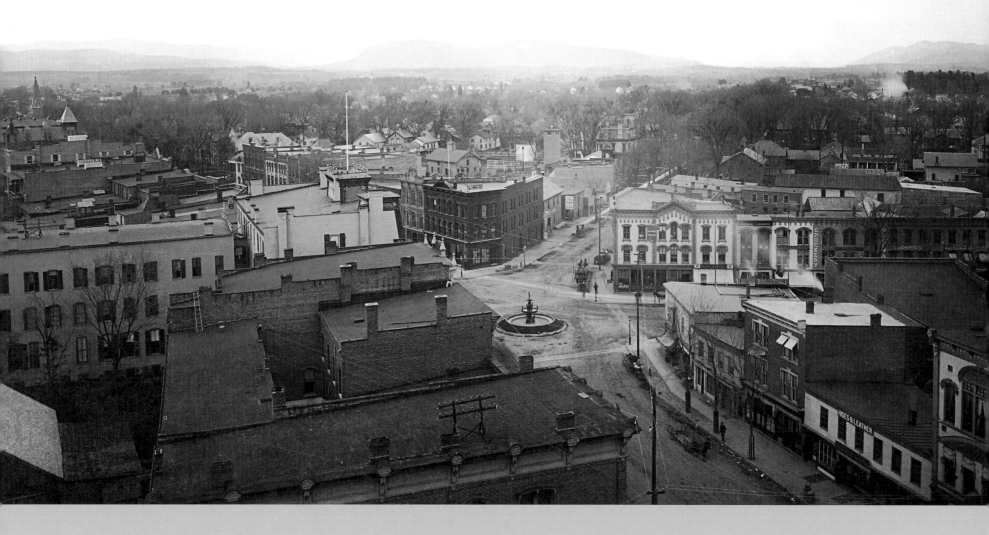

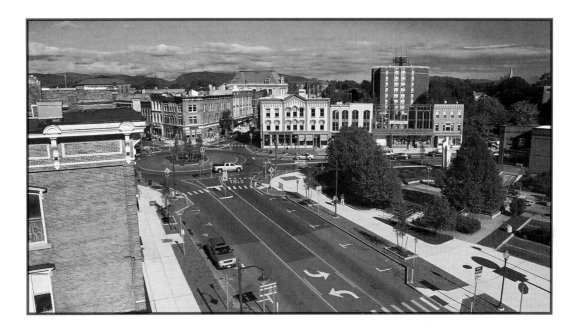

GLENS FALLS
North from Chimney of
Electric Light Building
ca. 1880

Certain re-creations have a special allure to me, based on the subject or the differences seen through time, or even the efforts required to shoot them. This is one of my favorites. I wanted to re-create Stoddard's fabulous overview to showcase the dramatic changes in his home city since his era. We're viewing Glens Falls' main intersection. Glen Street enters from the south. Warren Street intersects it from the east, Ridge Street from the northeast, and Hudson Avenue from the west.

Searching for Stoddard's vantage point, I entered a three-story office building on the west side of Glen, once home to the major local newspaper, the *Glens Falls Post*. I rode the elevator to the top floor. Through office door windows, I could see side windows that looked out over the city. The viewing angle was similar to Stoddard's. I met the building's owners, Peter and Suzanne Hoffman, who agreed to escort me to the roof. In the center of an office, we climbed atop a tall ladder, then, in a hair-raising maneuver, hoisted ourselves through a hatch in the ceiling. We scrambled up a short staircase and through a trapdoor to the roof.

We were rewarded with a spectacular panoramic view of the city. The scrollwork along the roofline of the adjacent building to the north confirmed we stood atop the same building Stoddard had. However, we couldn't get nearly as high as he did; the chimney from which he took his picture was long-gone. Whereas his higher vantage point allowed him to shoot over the adjacent building to the water fountain in the intersection, I was forced to shoot to one side of the building. Regardless, our shots show a remarkable evolution. Few buildings remain from Stoddard's era. There are a cluster of original facades at the intersection of Glen and Warren Streets, but most buildings have been rebuilt from scratch or renovated beyond recognition. The intersection itself has changed substantially. The water fountain was removed long ago. In 2007, a roundabout was installed. To the south, a small park and a Burger King parking lot occupy the footprint of the buildings lining Glen Street in the lower right of Stoddard's view.

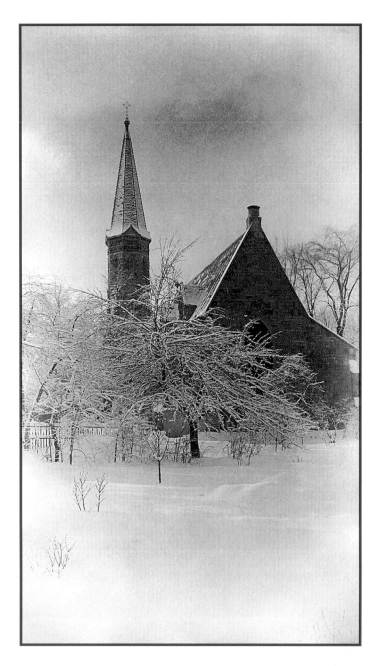

I waited to photograph this scene in a snowstorm, and the result is remarkably similar to Stoddard's image, with some notable differences. We're viewing the backside of the church. An addition was built since Stoddard's day. The steeple occupies the same position, but a tall chimney now rises near the front. The landscaping has also changed. A giant spruce now dominates the south lawn.

◀ CHURCH OF THE MESSIAH
Glens Falls
ca. 1880

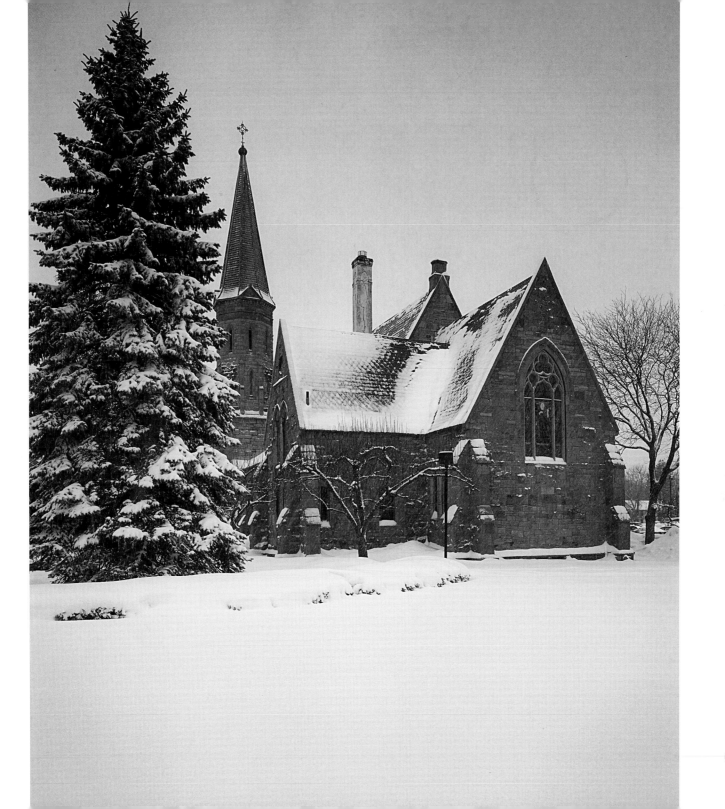

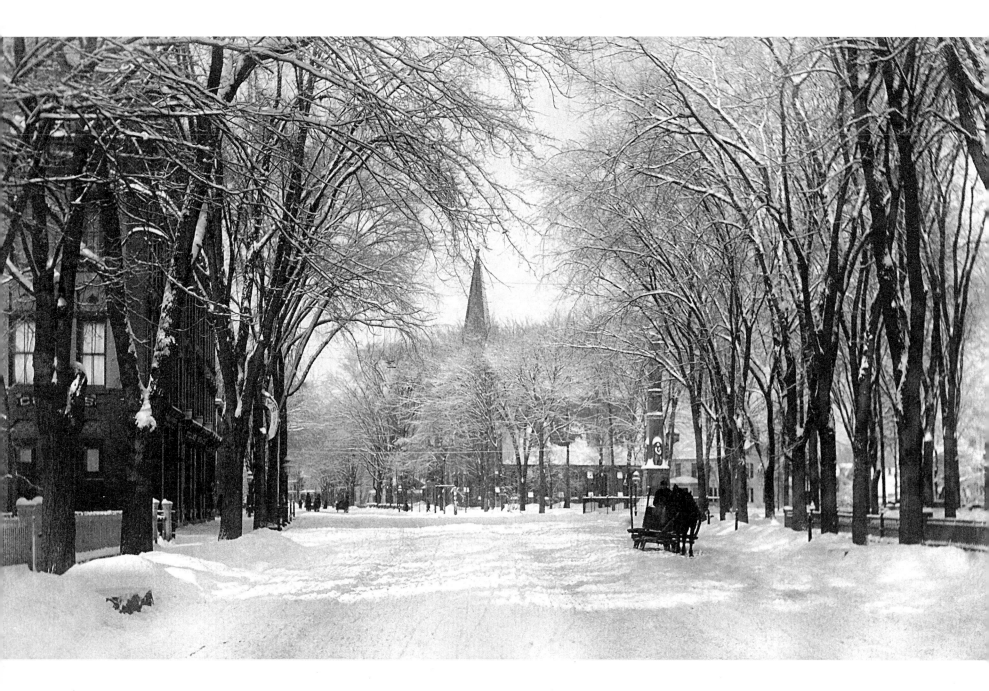

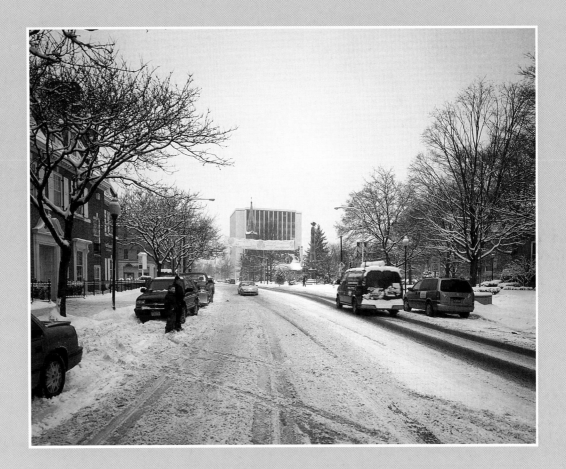

As Stoddard had, I wanted to photograph this scene from the middle of Glen Street. I was pondering how to do it without standing in traffic, when a large delivery truck double-parked in one lane. I quickly set up my tripod just off its back bumper, out of harm's way, and made the image.

Note the Civil War Monument and the steeple of the Church of the Messiah rising in the background of both images. The eleven-story Continental Insurance building now dominates the view north.

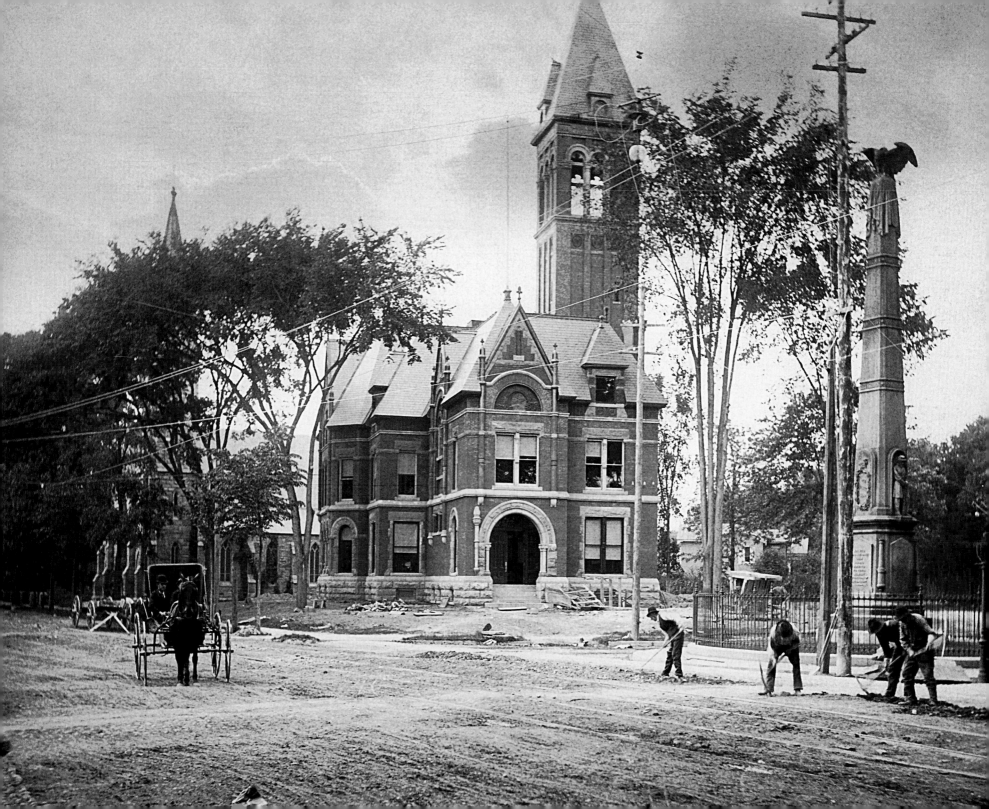

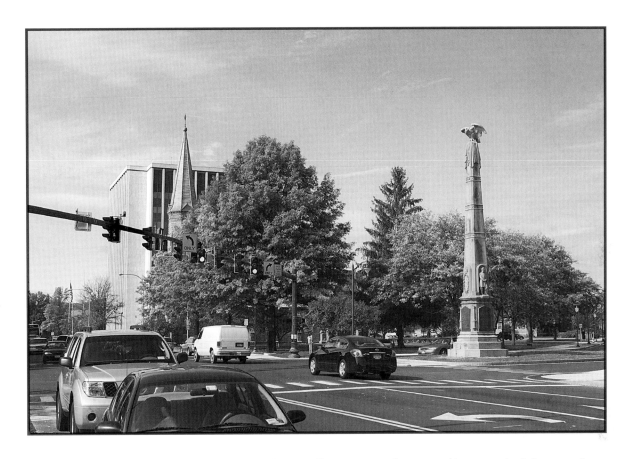

◀ CIVIL WAR MONUMENT &
INSURANCE BUILDING
Glen Street
ca. 1891

There's a miniature park now where the formidable brick building of the Glens Falls Insurance Company (the second of three versions, completed in 1891) rose between the Church of the Messiah and the Civil War Monument. Note that the fence around the monument has since been removed.

This intersection, where Bay and South Streets converge on Glen Street, is now one of the busiest in the city. Stoddard's studio was about one block west of here, on Elm Street. An unceremonious warehouse stands there today.

Stoddard's image demonstrates a technique he employed often: he combined two negatives to make his print—one for the foreground subject and a second of cloud features. In some cases the lighting conditions did not permit him to record both the foreground and the sky on one negative, because the emulsion did not offer an adequate range of sensitivity. In other cases he simply preferred to use a different background. As a consequence, multiple prints of the same subject feature different skies. In many prints one can discern where Stoddard dodged the horizon to avoid overlapping details from the two negatives.

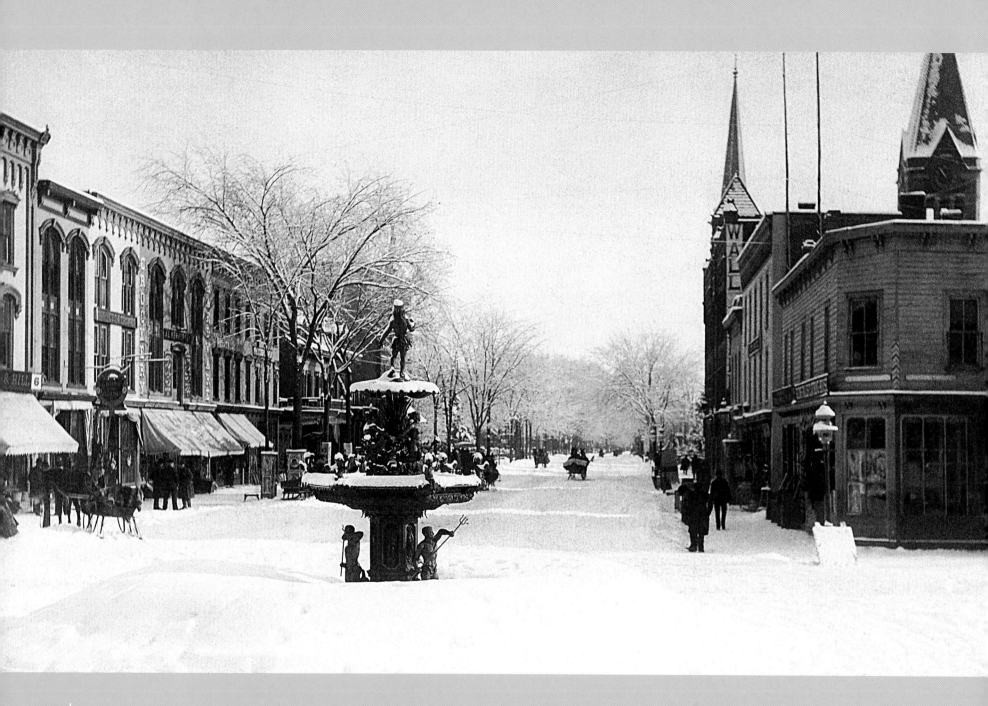

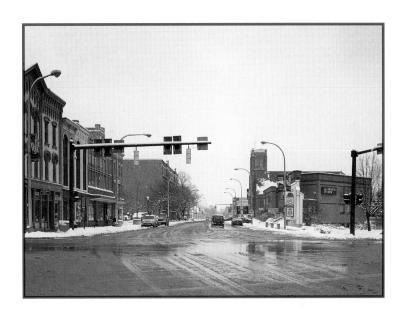 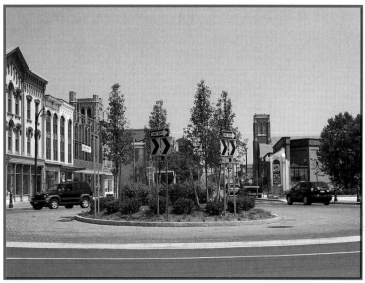

This radial intersection of Hudson Avenue and Glen, Warren, and Ridge Streets is one of several locations in the region that has changed so much in the few years since I made a re-creation of Stoddard's image that I returned to photograph it again. They are testaments to our rapidly changing world.

The building facades on the left side of our images are some of the few in the city center that have survived through the years; the rooflines and vertical windows remain intact.

The steeple nearest Stoddard's position—that of the Presbyterian church—is no longer there. St. Mary's steeple, beyond, was removed as a potential falling hazard, and the brick tower was capped.

The Neptune Fountain in Stoddard's picture was removed in 1897 in favor of efficient traffic patterns. Traffic lights controlled the flow of vehicles for many years. Recently the intersection was redesigned; the lights were removed and a single-lane roundabout was constructed.

◀ WARREN STREET FROM
ROCKWELL HOUSE
Glens Falls
ca. 1880

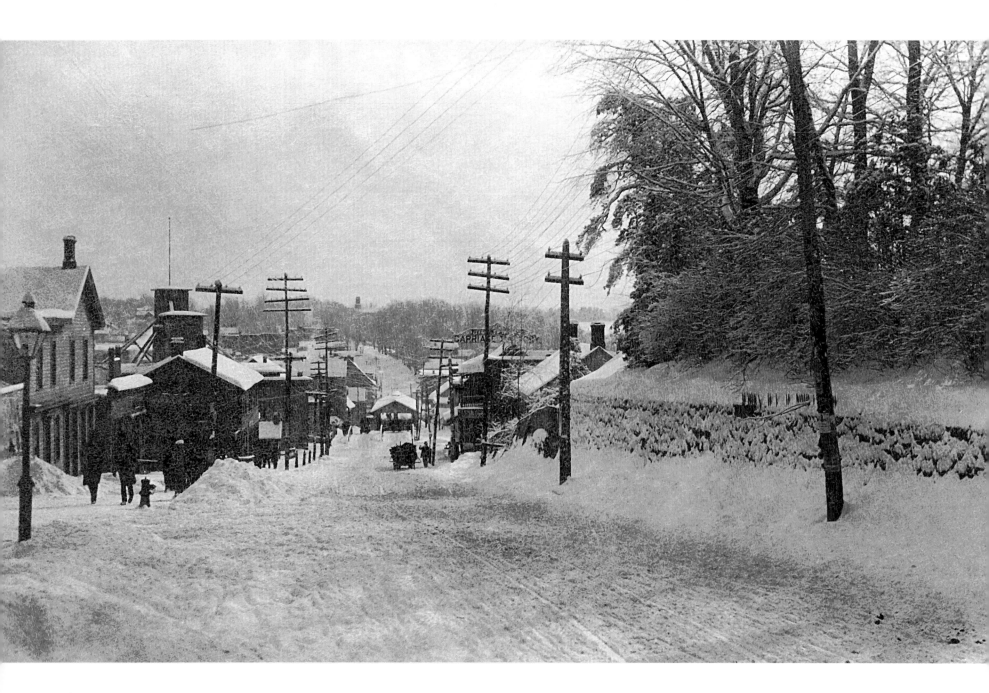

◀ DOWN THE BIG HILL
Glen Street
ca. 1875

The quaint covered bridge that once spanned the mighty Hudson River was replaced by an iron bridge in 1890. Twenty-three years later, logs carried by a spring flood destroyed the bridge. The modern open span offers views of the city's namesake waterfalls, which have for many years powered paper mills.

The Glens Falls Civic Center now occupies the east side of the Glen Street hill, where once stood several businesses.

Stoddard wrote of Glens Falls in 1905, "It is the metropolis of Northern New York, the market and source of supplies of a large tract of rich outlying country east and west, and is the center of industries and enterprises outward to points that has made it of national importance."

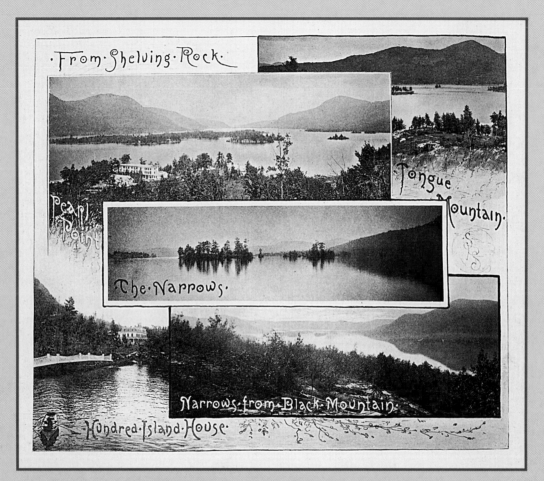

Photogravure, from *Lake George, A Book of Pictures*, 1888

Compiled by
.R. STODDARD,
GLENS FALLS, N.Y.
ty Sixth (Revised) Edition
1904

Lake George

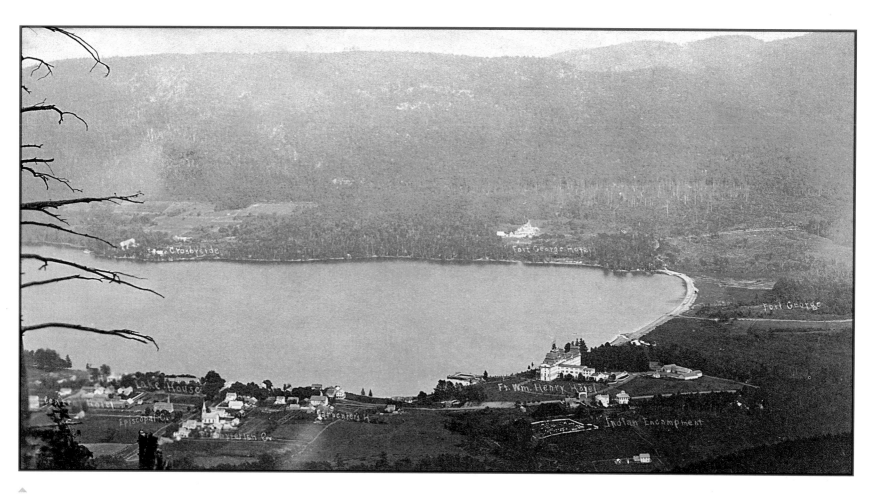

LAKE GEORGE (CALDWELL)

from Prospect Mountain ca. 1875

Lake George was the closest Adirondack tourist destination to Stoddard's Glens Falls studio, and he made the seven-mile journey to the south shore many times. The village, originally known as Caldwell, has become a tourist mecca, drawing hundreds of thousands of visitors each year. Hotels, motels, restaurants, and shops line Canada Street and the Beach Road. Like the steamboats of Stoddard's era, modern cruise ships dock here, offering scenic cruises up the lake.

Stoddard's labels are interesting. In the village, there's the Central Hotel and the Lake House, the Episcopal and Presbyterian Churches, and Carpenter's House. He also marked Fort George at the south end of the lake, and the Fort George Hotel and Crosbyside—another inn—on the east side. Note the Indian Encampment near the Fort William Henry Hotel. For many years, Indians came down from Canada in the summer to sell handmade souvenirs to tourists.

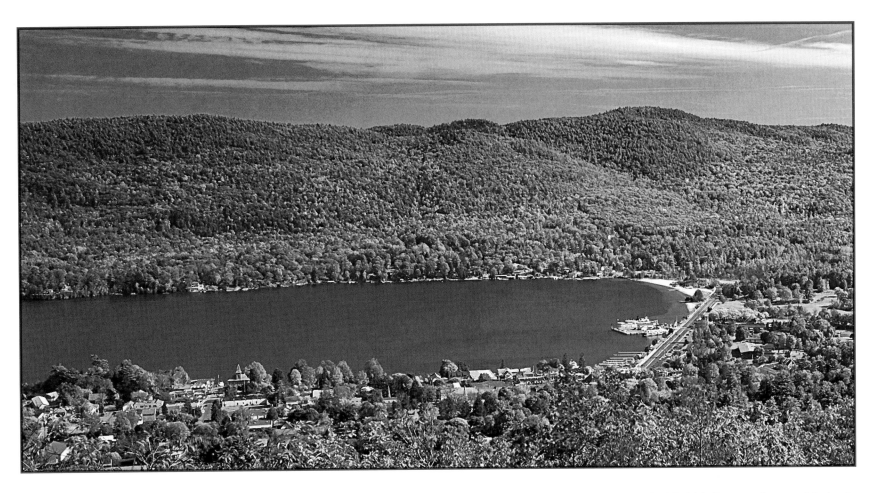

The replica of Fort William Henry, conspicuously absent in Stoddard's shot, was not completed until 1953. The original British fort was destroyed in battle with the French and their Indian allies in 1757.

The shape of the lakefront hasn't changed appreciably, but the denuded hillsides Stoddard saw have since filled in with trees. The mountains above the east shore are protected within the Lake George Wild Forest. Even the village, though densely packed with businesses and homes, is much leafier today. This dichotomy exists across the Adirondack Park: pockets of intense development are visually screened by mature, aesthetically pleasing foliage.

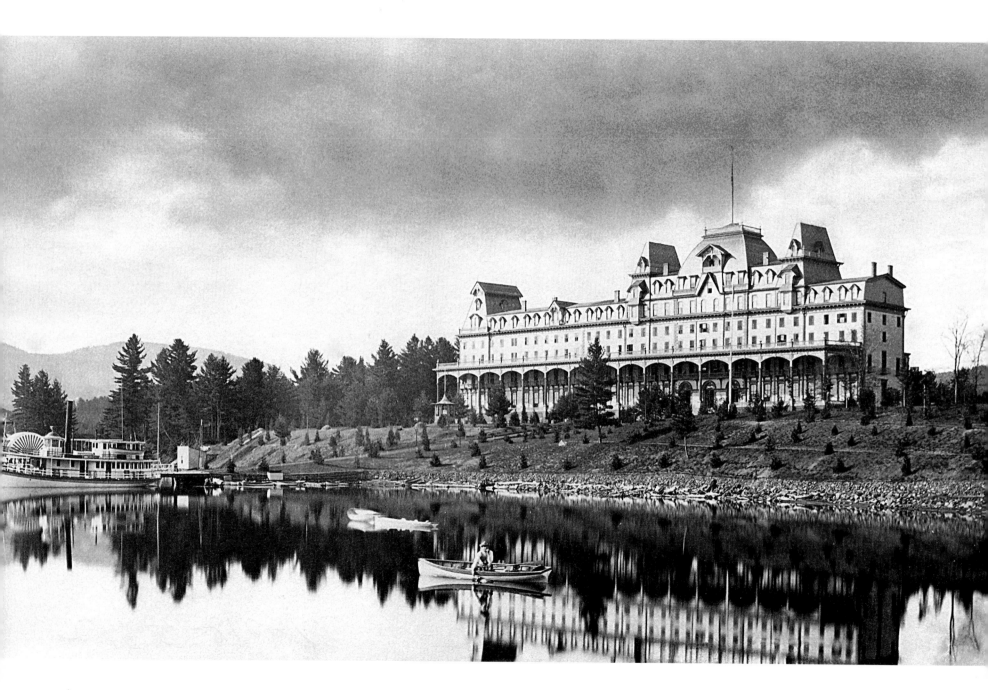

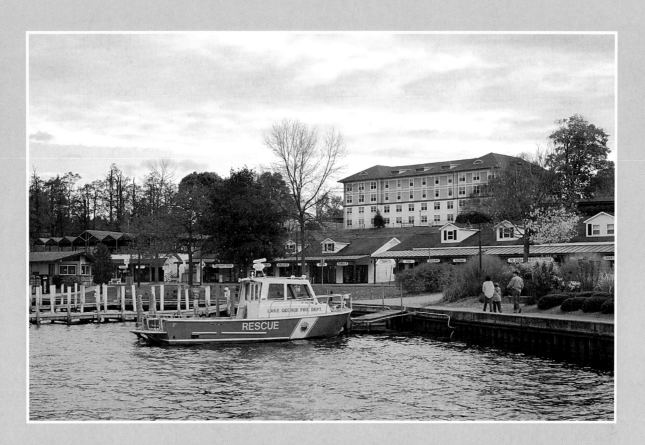

**FORT WILLIAM
HENRY HOTEL**
Lake George (Caldwell)
ca. 1875

In the late nineteenth century, documentary photographers like Stoddard recorded the influx of tourists in the age of the grand hotels. The original Fort William Henry Hotel, opened in 1856 and remodeled in 1868, catered to the "Great and the Gracious." It was a lavish Victorian structure that eventually grew to one thousand rooms. Tragically, it burned to the ground in 1909. Within a year it was replaced by a more modest unit. In 2003, a new five-story hotel was erected on the site amid much controversy over whether it would negatively impact scenic values, yet it pales in comparison to the former hotel's magnificence. This trend prevails throughout the Park: lodging units, though more plentiful, are more modest in scale and architectural detail than their counterparts of yesteryear.

The beautiful Adirondack guideboat of Stoddard's view has morphed into the Lake George Fire Department Rescue boat of mine. It emphasizes the evolution of boats on the lake. Today there's a resident fleet of over ten thousand pleasure and commercial craft on Lake George. The village lakefront is lined with souvenir stores, food stands, and parasail and cruise-boat docks.

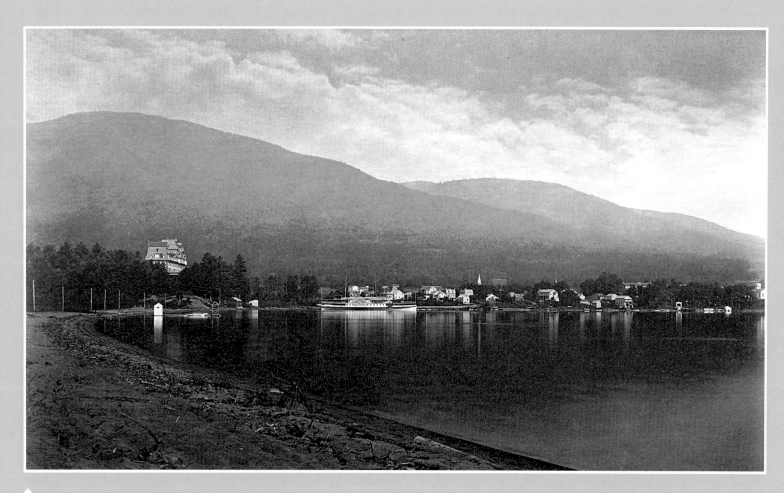

Lake George
(Caldwell)

From the East
ca. 1875

I was able to align Prospect Mountain and the curving beach with Stoddard's view. Little else is similar. He captured the steamer *Horicon* at dock in front of the Fort William Henry Hotel. The pier to which the *Horicon* was moored no longer exists. It was a substantial, forked structure with a hole to the water in the middle that allowed vessels to enter and be sheltered from the weather.

Today's familiar steel pier was built further east, at the site of the previous Delaware-Hudson Railroad wharf. Train tracks extended to the wharf's tip, where goods and supplies were off-loaded for steamer transit up the lake.

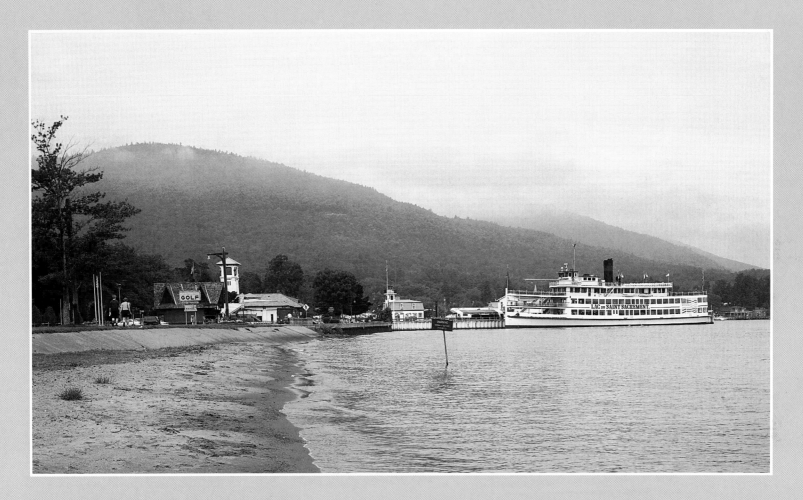

Train service was halted in the mid-1900s and the tracks removed. The railroad station, whose distinctive tower still looms over the dock, now houses a gift shop. The pier is home port to the modern cruise ships *Lac du Saint Sacrement, Mohican,* and *Minne-Ha-Ha.*

In Stoddard's day, a dirt road paralleled the shore, the precursor of today's Beach Road. The state-owned Million Dollar Beach, opened in 1953, lies just east of our positions. Again, there was no Fort William Henry for Stoddard to photograph.

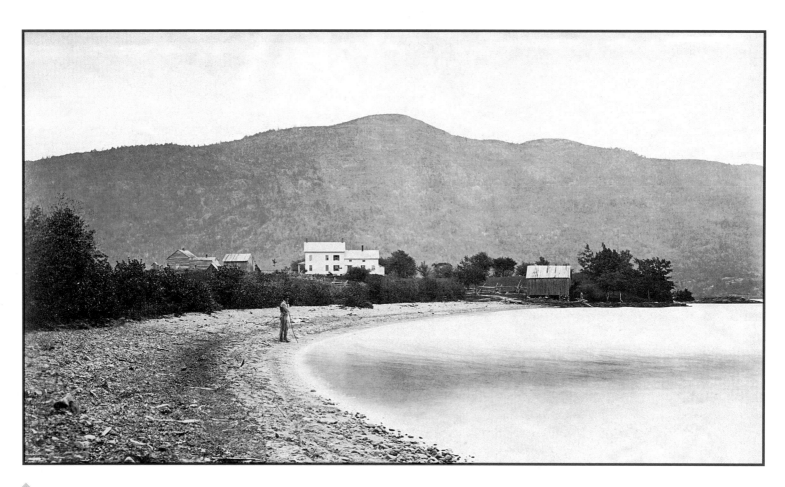

SABBATH DAY POINT
Lake George
ca. 1875

Sabbath Day Point is ideally situated about halfway up the northern arm of the lake, on the west side, beneath the north end of the Tongue Mountain Range. It was a convenient stopover and lookout during the French and Indian War and the Revolutionary War. Historians note that, during the mid-1700s, not a single tree had been left standing on the point; they'd all been cut for building and firewood—and to open lake views.

Today Sabbath Day Point hosts a community of summer homes. Pleasure-boat docks have commandeered the tranquil crescent beach of Stoddard's day, one of the most beautiful natural beaches on the thirty-two-mile-long "Queen of American Lakes."

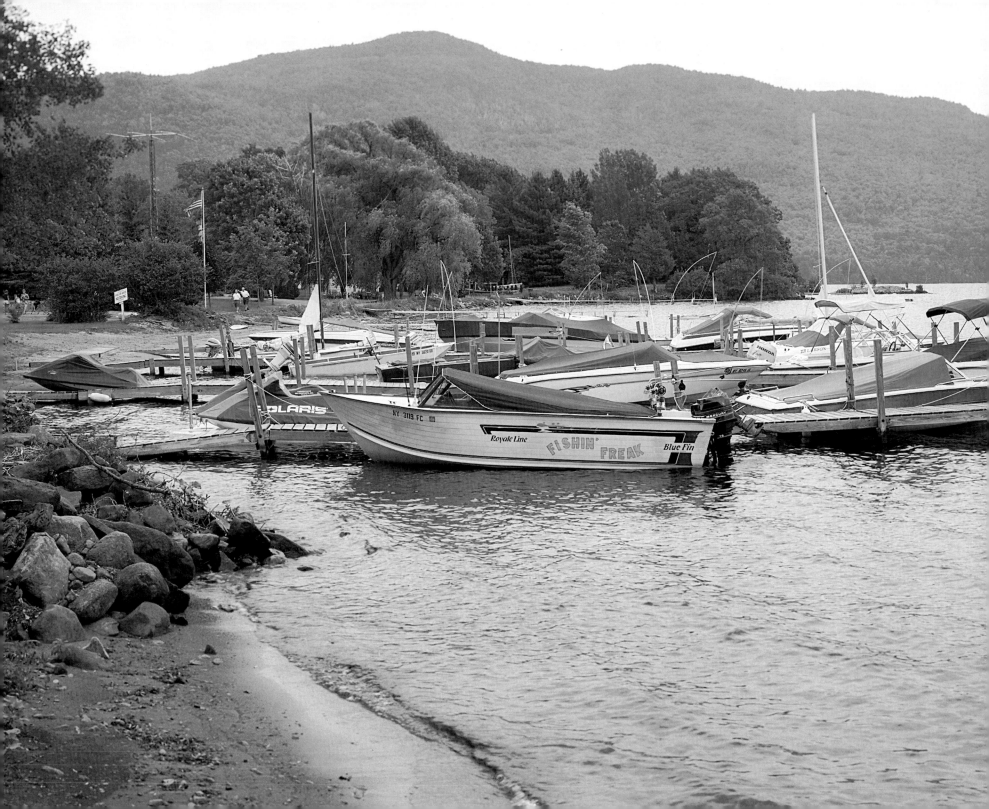

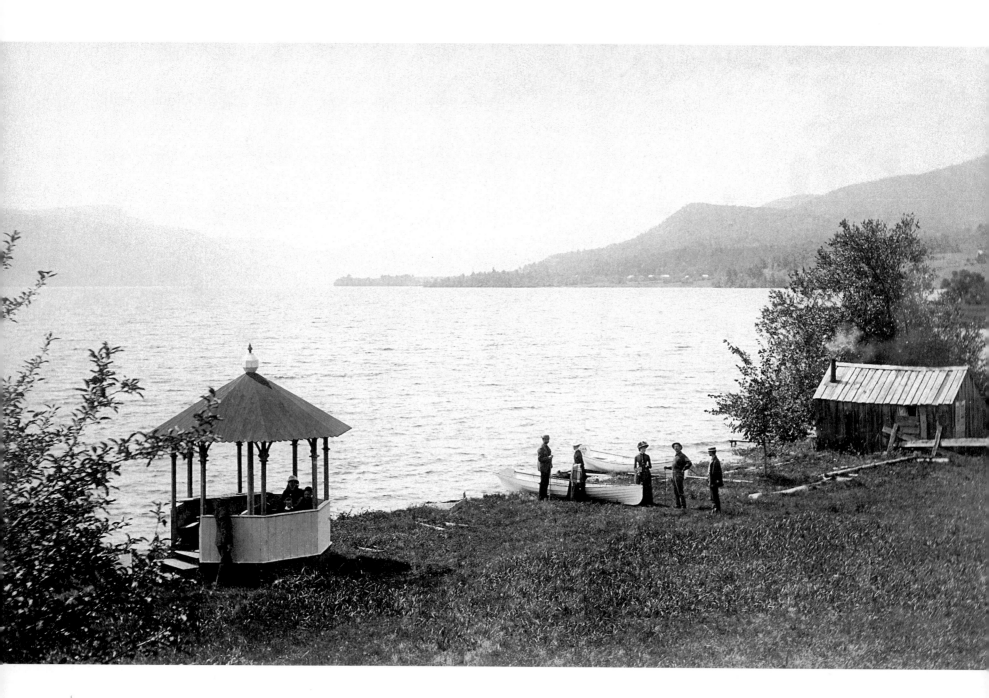

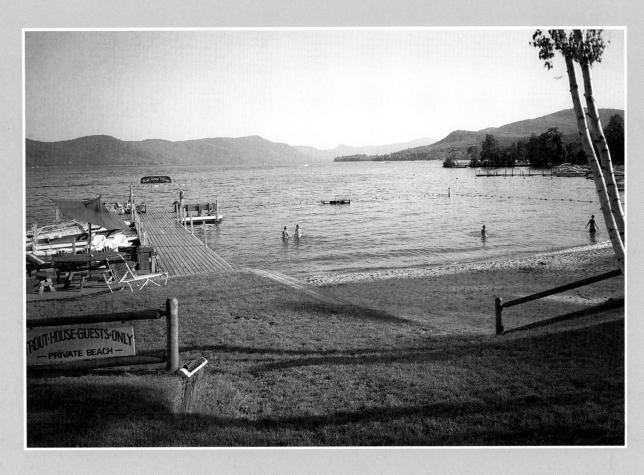

◄ VIEW AT HAGUE
Lake George
ca. 1875

Early settlers often clear-cut the woodlands around new communities and used the timber for building. As a result, water views were also opened. This view is southeast across the lake to Sugarloaf and Black Mountains.

The gazebo in Stoddard's scene was the property of the Trout House, a lodge originally situated at the north end of today's Trout House Village Resort.

Where once grass and scrub brush ran down to water's edge, sand was hauled in to create a beautiful beach. In summer, the resort owners furnish the wooden pier with Adirondack chairs for guests to enjoy the scenery, like the first guests had from the gazebo.

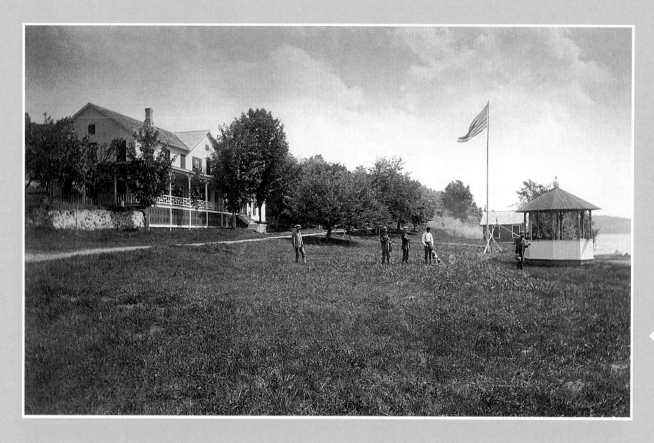

TROUT HOUSE
Hague
ca. 1875

The dirt track heading north past the Trout House was the precursor of today's Route 9N, a rambling scenic byway hugging the western shore. The Trout House Village Resort now straddles the road.

The invention of the automobile, late in Stoddard's life, ushered in the golden age of travel. Long-distance vacations became affordable to many families, and small motor inns, motels, and resorts like this one sprang up across the Adirondacks. Many offered recreation and entertainment packages with all amenities included: dining, shows, sightseeing, horseback riding, tennis, volleyball, boating, swimming, and indoor games.

The quaint hamlet of Hague was initially named Rochester. The name was changed in 1808 when it was found that another New York town had already selected it.

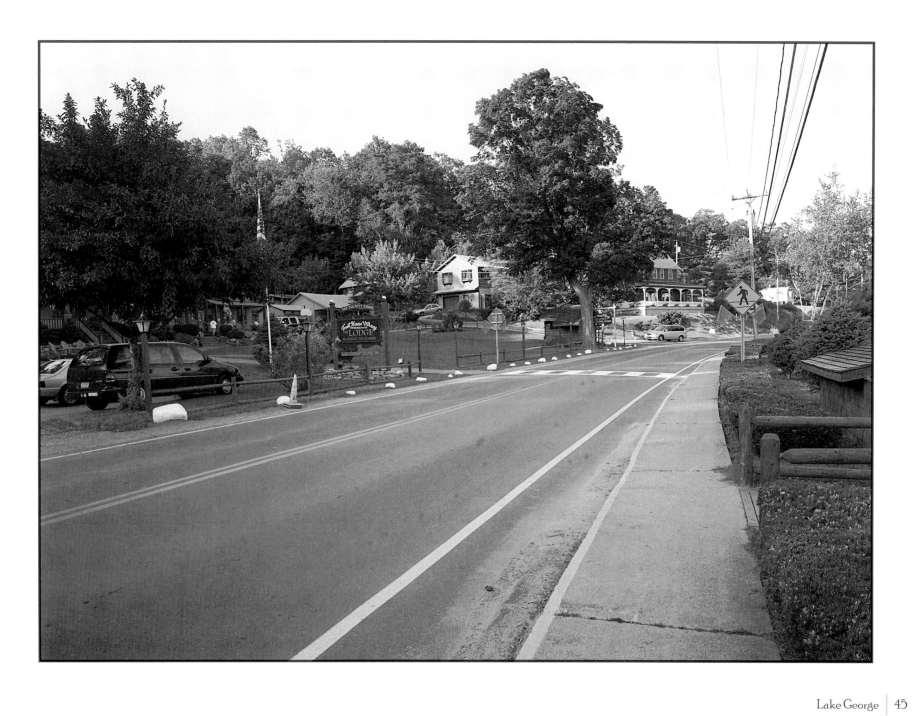

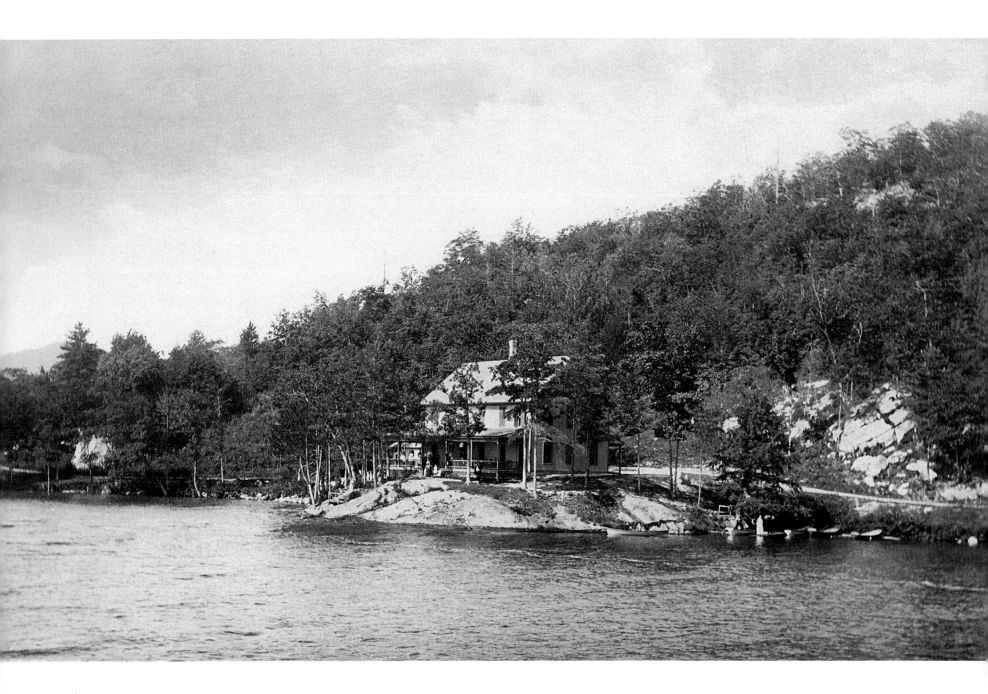

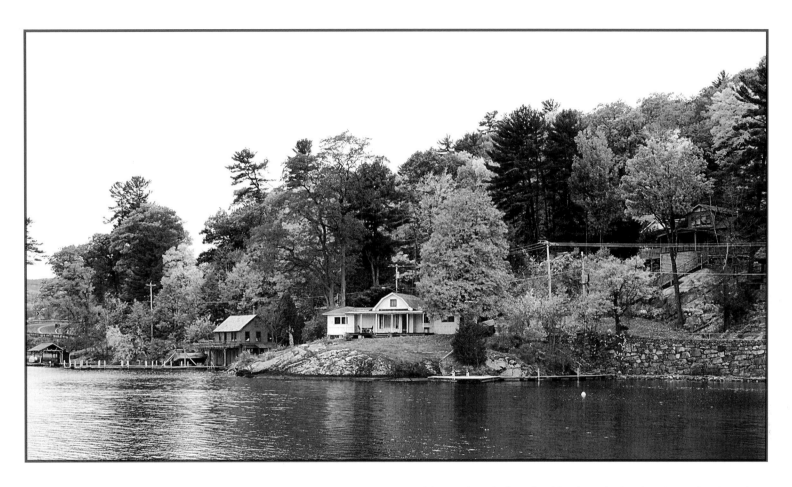

ISLAND HARBOR

Hague
ca. 1875

This protruding outcrop has hosted a private residence since before Stoddard's arrival. It juts into Island Harbor, within swimming distance of the Cooks Islands.

You can follow the winding road, now Route 9N, through both shots; the rock outcrops on the far right of the images are still prominent.

ISLAND HARBOR PENINSULA
from Beatty House
ca. 1875

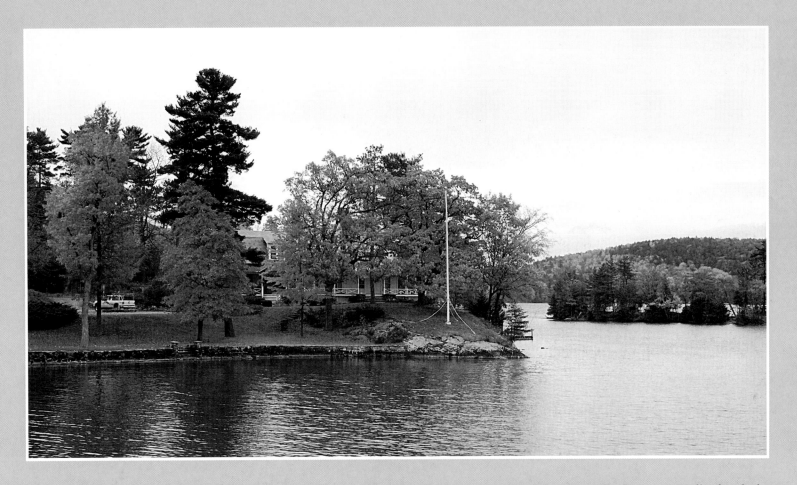

In Stoddard's day, this beautiful peninsula, with scenic vistas to the Cooks Islands, was a great spot for a campsite. Later, a sprawling hotel—the Island Harbor House—occupied the peninsula. The house that is currently there had originally been built as a cottage on Waltonian Island, just offshore. In 1917, the owner, Colonel Mann, had the cottage divided into three pieces and dragged across the ice to the mainland. Upon his death in 1922, the hotel proprietors purchased the cottage. They used it as a guesthouse until the hotel burned down in 1933, then converted it into the main hotel building. Today it is a private residence.

Where Stoddard saw boats pulled up on a beautiful sand beach, a stone wall now protects the shoreline from erosion by waves and ice.

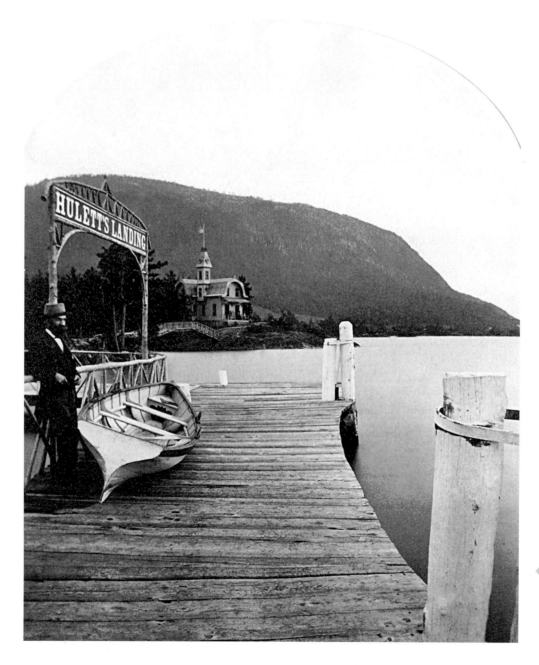

◀ HULETT'S LANDING
THE ELEPHANT
Lake George
ca. 1875

In Stoddard's era, this small peninsula protruding into the northern arm of Lake George hosted a Victorian-style "gingerbread" hotel, standing proud beneath the ridge known as The Elephant. Much of the hotel was destroyed by fire in 1913. Another was built in its place, which operated until 1949. Today this lovely spot hosts a private residence.

Wealthy tourists came to the Adirondacks seeking leisure, adventure, and revitalization. They brought with them a sense of propriety—an evolving blend of Victorian and early American ethics—imparting civility on a wilderness being tamed. Seneca Ray captured that spirit in his photos of their fashion and architecture.

Stoddard published this image as part of a stereograph. Though the dock no longer exists and I couldn't stand as far out over the water as he did, I easily traced the curvature of the shoreline and the outline of the ridge. In 1905, Stoddard wrote, "The Elephant stands back there at the north end of Black Mountain. Note his well formed head towards the west; his eye; the rift that marks the outline of his massive jaw; the wrinkled neck and great rounded back with scattered bristles of dead pines clearly defined against the sky beyond."

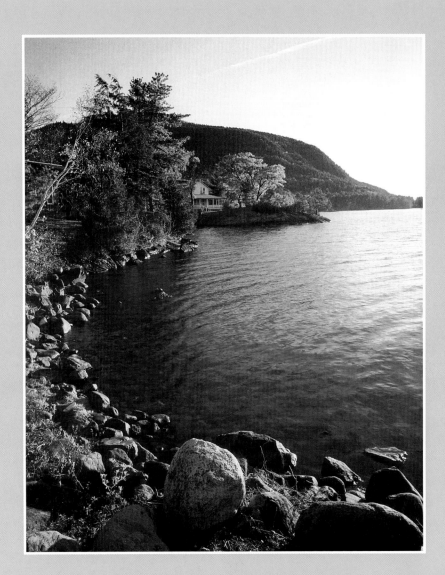

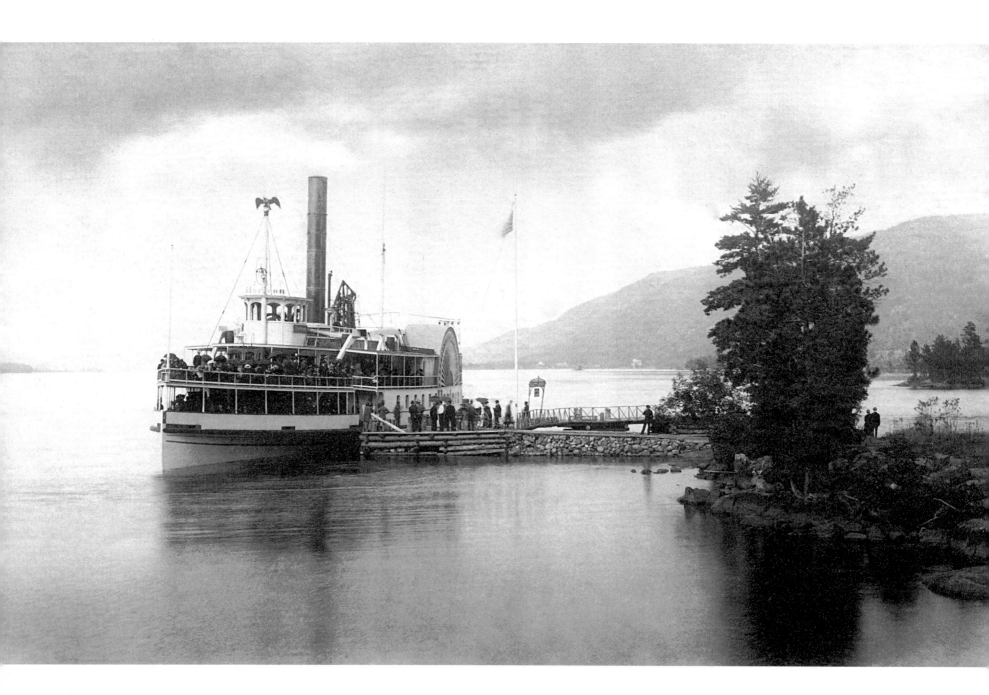

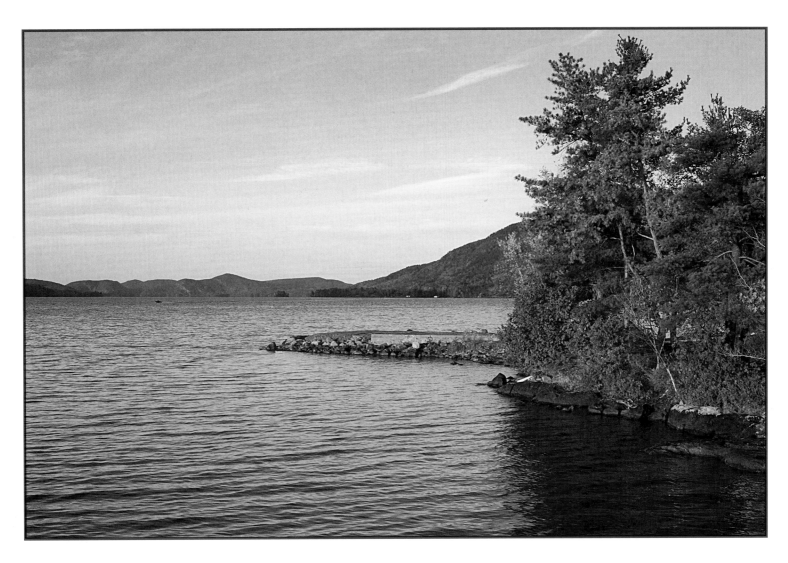

◁ HULETT'S
LANDING DOCK
Lake George
ca. 1875

As if wiped clean by the hand of God, this is all that remains of the steamboat dock at Hulett's Landing. The cruise ships no longer stop here. Hulett's is off the beaten path, reachable either from the lake or a long drive around either end, then up and over the eastern mountains. It's a sleepy lakeside community that reawakens each summer with the return of second-homeowners and tourists.

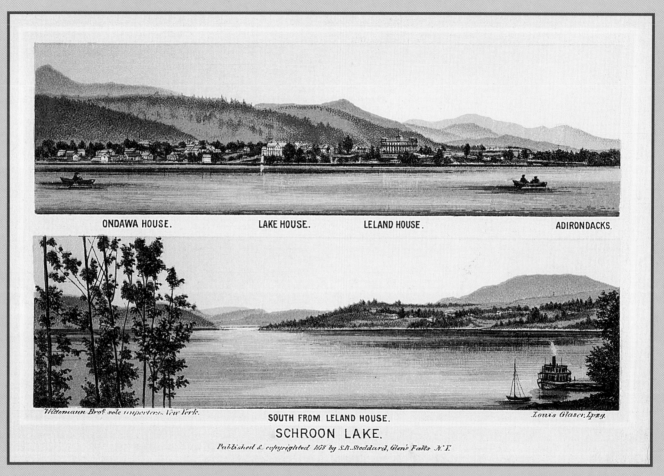

ONDAWA HOUSE. LAKE HOUSE. LELAND HOUSE. ADIRONDACKS.

Wittemann Bro§ sole importers. New York.

SOUTH FROM LELAND HOUSE.

Louis Glaser, Lpzg.

SCHROON LAKE.

Published & copyrighted 1878 by S.R.Stoddard, Glen's Falls N.Y.

Plate 18, Schroon Lake, from *The Adirondacks*, 1878

Southeastern Adirondacks

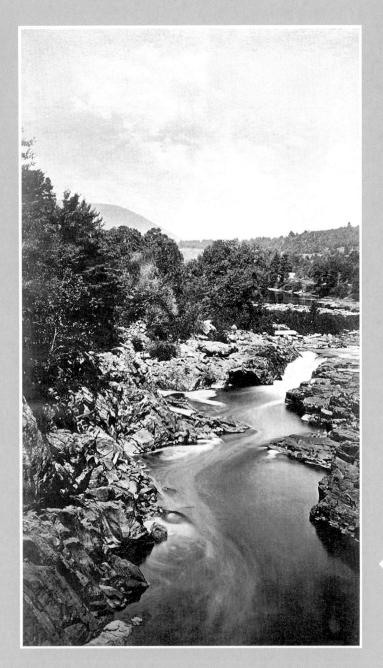

Timbermen once floated logs to mill on the Hudson through this gorge on the Hadley-Luzerne line. Now called Rockwell Falls, it was widened by blasting to prevent logjams. Truck transport replaced the practice of running logs to mill via local waterways, once widespread across the Adirondacks.

The gorge is a popular, albeit dangerous, swimming hole. The churning river is so powerful it has sculpted perfectly round potholes in the bedrock lining the banks. Downstream, near the confluence of the Sacandaga River, is a take-out point for guided whitewater rafting trips.

We both photographed this scene from a bridge high above the river.

LUZERNE FALLS
Hudson River
ca. 1875

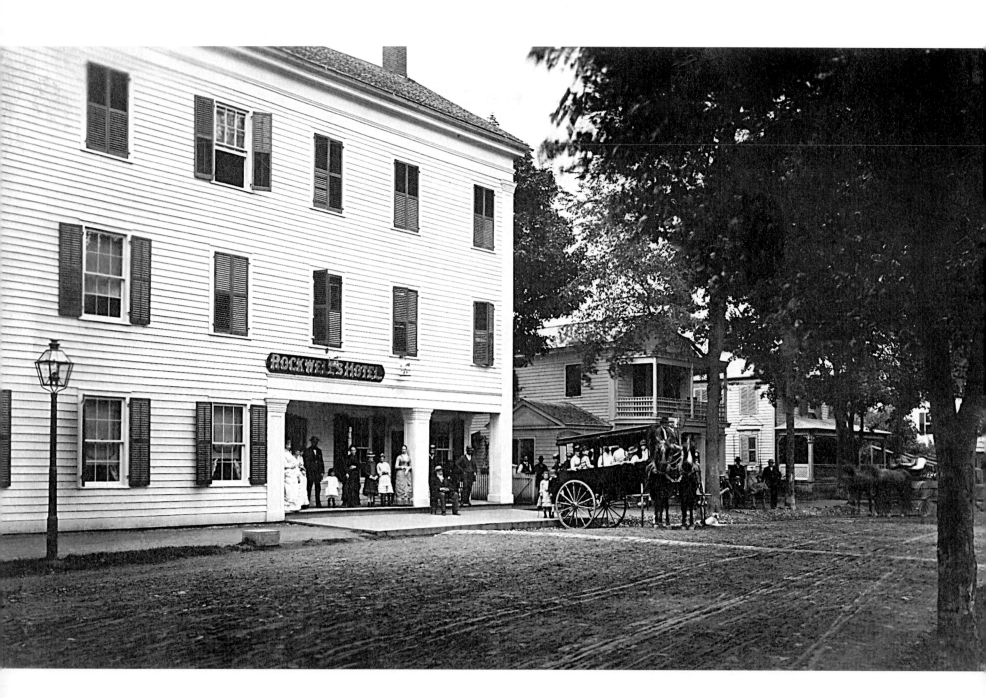

ROCKWELL HOTEL
Luzerne
ca. 1875

The Rockwell-Harmon Cottage and a village park occupy the site of the former Rockwell Hotel, built in 1832. The hotel and attached cottages could accommodate one hundred fifty guests. A local farm supplied many of the items on the menu. After years of ownership, George T. Rockwell claimed that he was the hotel proprietor of longest standing of any in the United States. He taught his sons the business. One, George H., became part-owner of the Rockwell House in Glens Falls.

Note how the old buildings literally fronted Main Street. The paved version of this well-traveled dirt avenue remains the main artery of this charming riverside village.

Stoddard enticed several people to pose for him. Since few people owned a camera, the novelty of being photographed and possibly appearing in print apparently helped coax total strangers to willingly pose en masse. A photographer requesting the same today—when picture taking has become so commonplace—would likely be looked at askance.

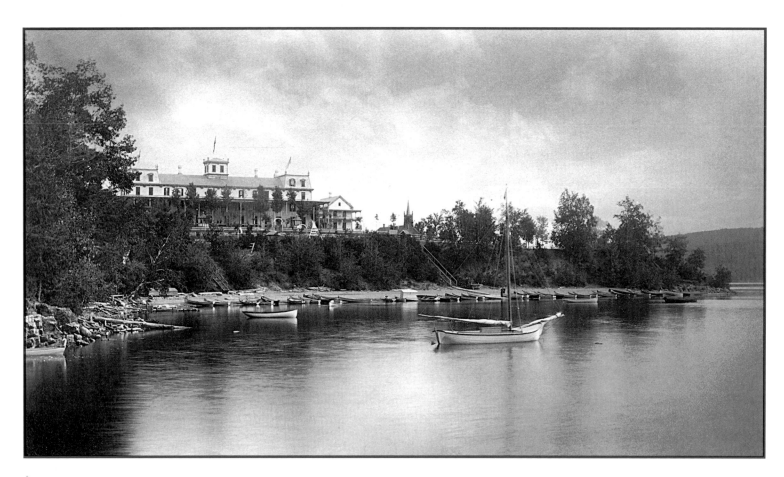

LELAND HOUSE
Schroon Lake
ca. 1880

From atop a plateau, the Leland House sported a commanding view over Schroon Lake. Built in 1872, it could host up to three hundred guests. Trout and venison were highlights on the dinner menu, and sherbet was served as a favorite dessert. The price for a week's stay was twelve to seventeen dollars.

On October 31, 1914—Halloween night—pranksters ran in and out of the churches on the main street, ringing the church bells. One prankster threw a cigar in the leaves, and the Leland House became engulfed with flames that could not be extinguished, because the water system had been turned off in preparation for winter.

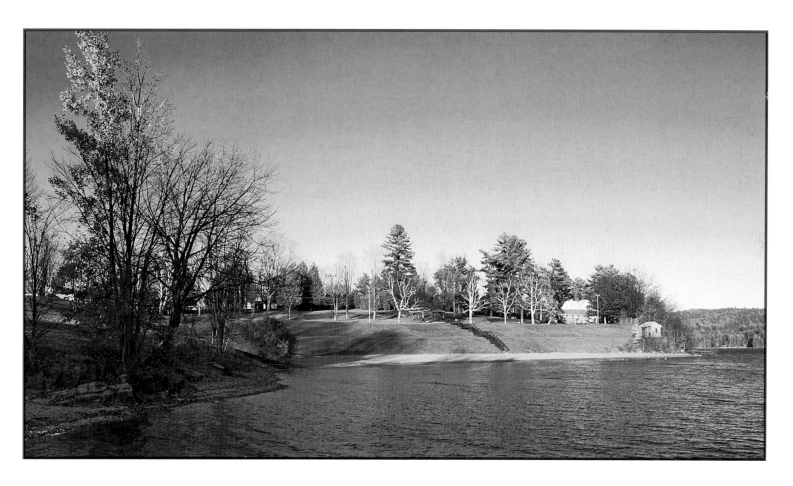

A public park now occupies the site. A wooden staircase still descends the slope to the town beach, which in summer is adorned with numerous white Adirondack chairs. But as the vacation season ends and the tourists and second-homeowners leave, the waterfront goes eerily dormant.

Imagine the value in today's currency of the boats in Stoddard's image!

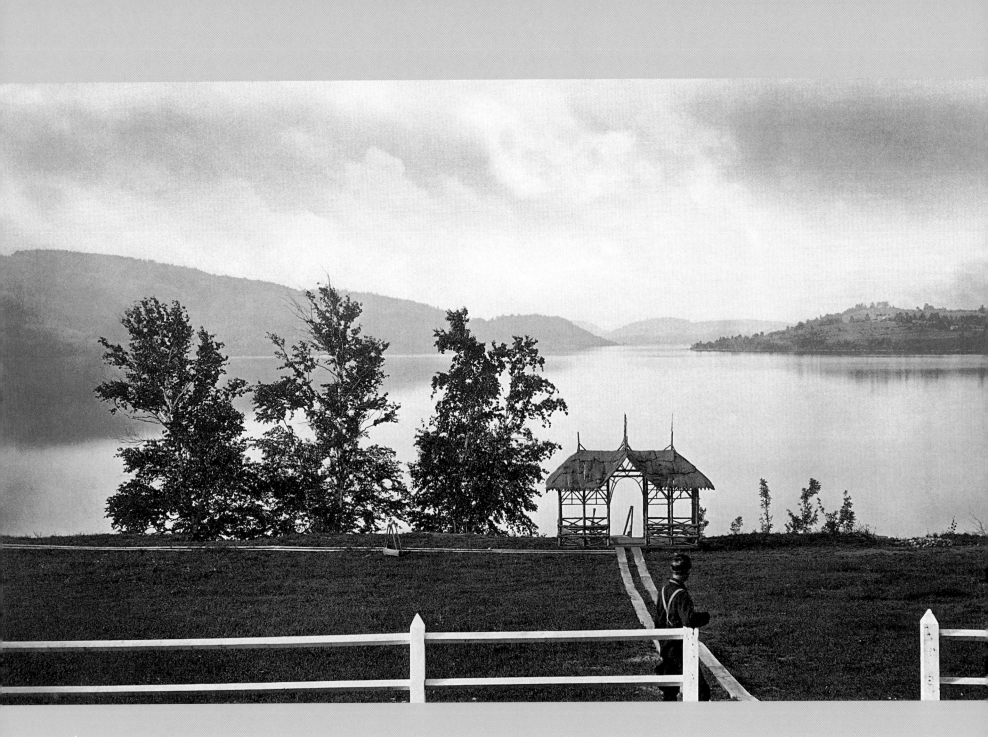

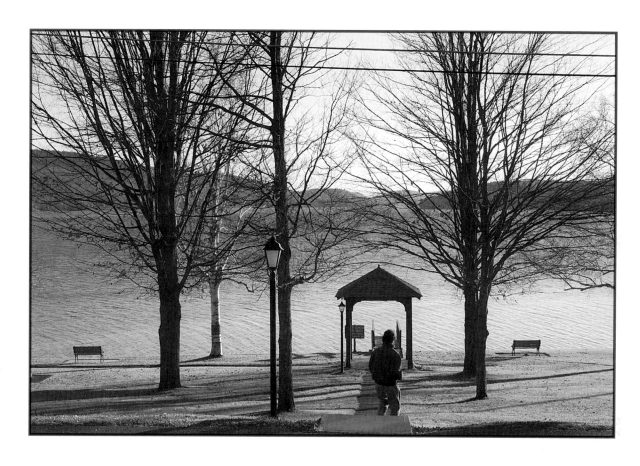

SCHROON LAKE
South from Leland House
ca. 1875

Two rows of planks served as a walkway from the Leland House down to a stylishly rustic gazebo at the head of the staircase to the beach. These two images speak of our traditions. The walkway is now paved, but a gazebo still overlooks the lake.

The three large trees in Stoddard's view are gone, but others have matured, filtering the once unobstructed views from the denuded plateau. Note also the deforested mountain in the distant right of his image. Trees now obscure numerous houses peppering its slopes.

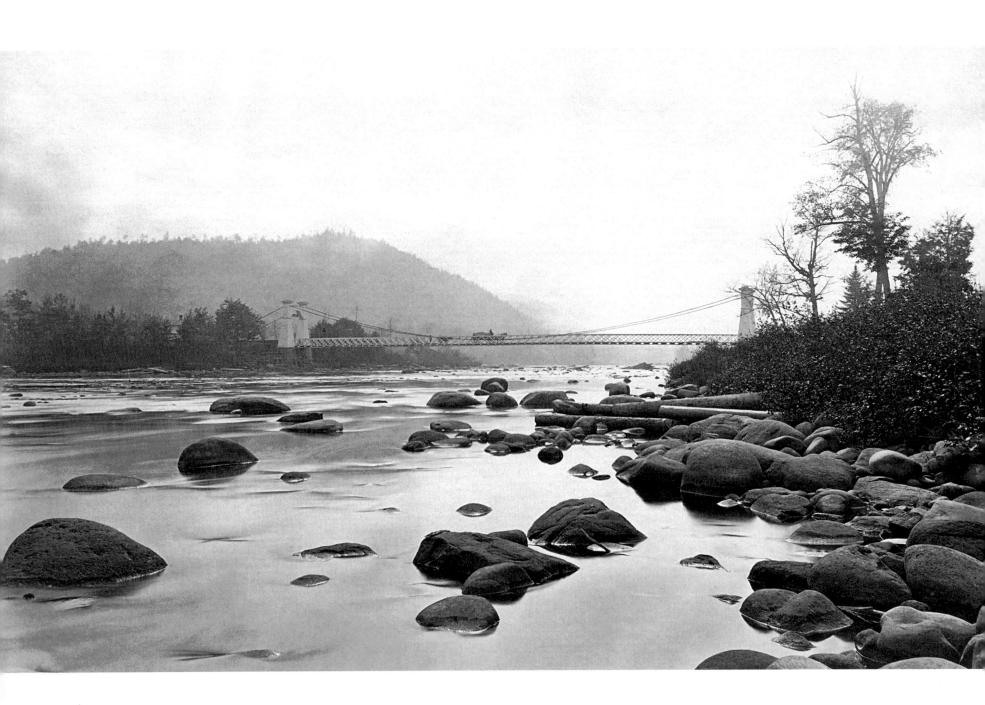

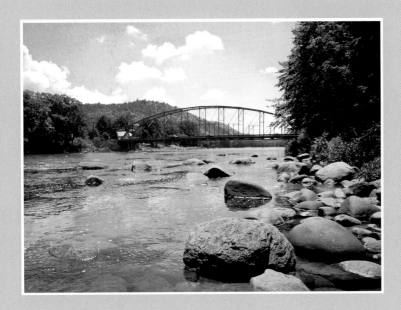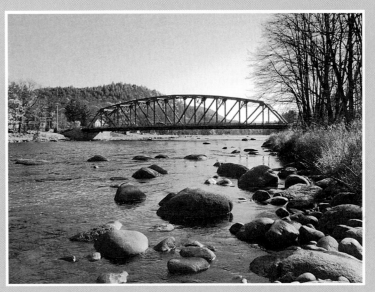

Looking downstream along the Upper Hudson River in Warren County, Stoddard captured a horse-drawn wagon crossing the regal suspension bridge built in 1871 by the renowned engineer, Robert Gilchrist. In contrast, I photographed an SUV on the 1920-built Pennsylvania camel-back steel truss. In 2004, to accommodate increased traffic volume on Route 8, a new two-lane span was constructed to replace the single-lane bridge, over which timed lights had controlled traffic. On a winter night, when there would be minimal disruption to traffic, the old bridge was slid on a custom track about forty feet upstream and connected to temporary ramps at either end. The new bridge was built at the original site of the old bridge and new on and off ramps were installed. The old bridge was later dismantled.

The cut forest on the right of Stoddard's image was cleared for the North Creek line of the Adirondack Railroad, which reached Riverside a year before the suspension bridge was built.

SUSPENSION BRIDGE
Riverside
ca. 1875

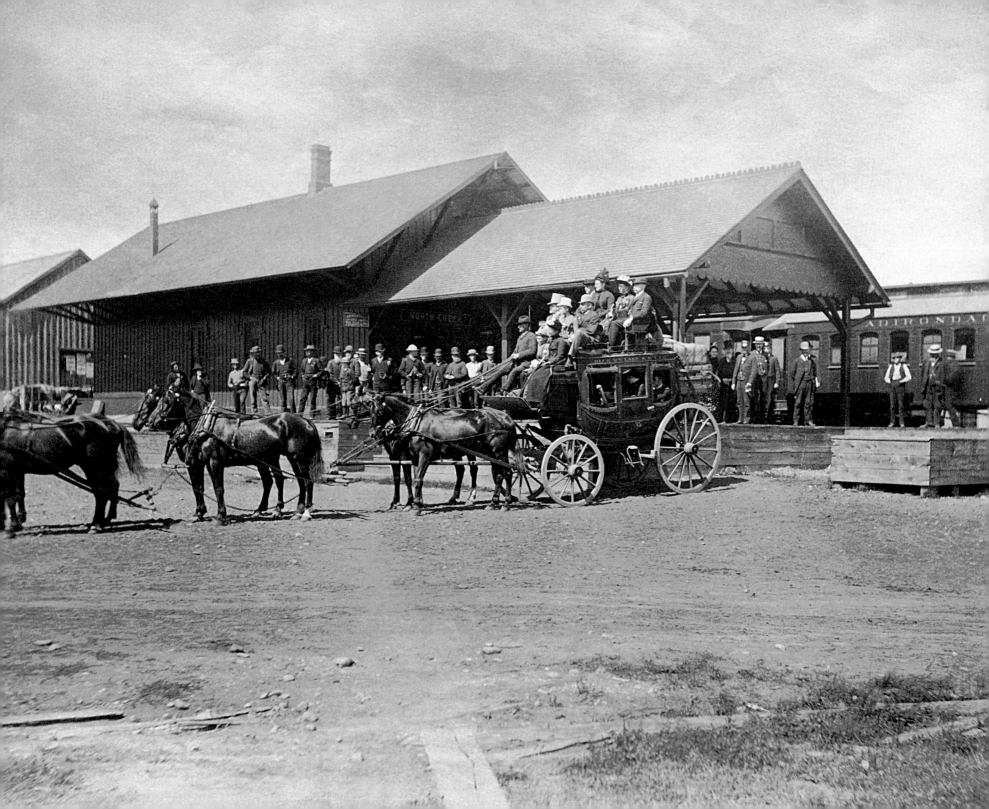

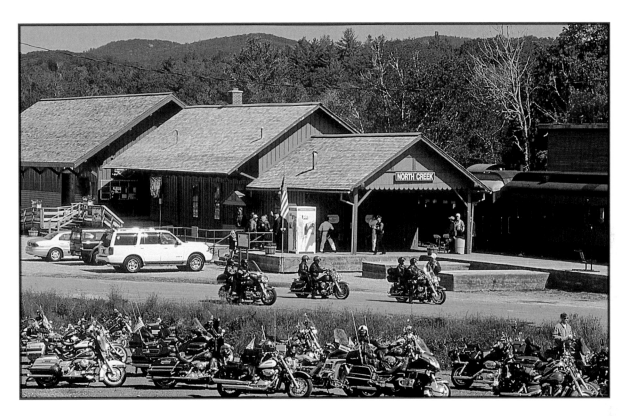

ADIRONDACK RAILROAD
North Creek
ca. 1890

Soon after the Civil War, Dr. Thomas Durant, General Manager of the Union Pacific Railroad, built the Adirondack Railroad line from Saratoga to North Creek. Durant would later help drive the golden spike at Promontory Point, Utah, that linked the nation's railroads.

Fortunately for Durant, the North Creek depot became the rail terminus for destinations in the central Adirondacks. In return for building the track to North Creek, he received hundreds of thousands of acres between Blue Mountain and Raquette Lakes. To service wealthy travelers, the doctor and his son, William West Durant, built stages, boats, hotels, and restaurants.

Starting in 1937, special ski trains transported thousands of snow lovers annually from downstate to North Creek, where they caught shuttles to Gore Mountain and other northern slopes. World War II ended the "ride up-slide down" trains. The exterior of the depot hasn't changed profoundly since Stoddard's day. It is now home to the Upper Hudson River Railroad, which makes sightseeing runs in the summer between North Creek and Riverside.

Where Stoddard photographed stagecoach riders, I found motorcyclists participating in the world's largest touring rally—the annual Americade—based in Lake George.

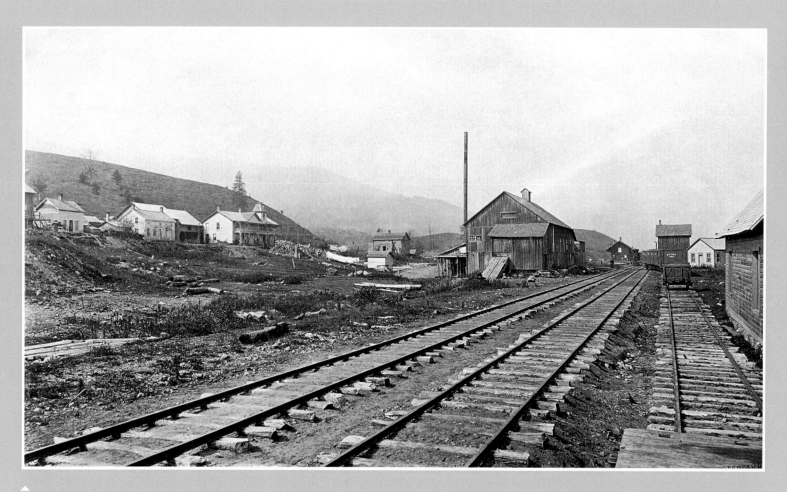

TERMINUS OF THE
ADIRONDACK
RAILROAD
North Creek
ca. 1880

Though the depot itself has changed little in the past century, some tracks and many of the rail sidings have been removed. Houses still overlook the rail line from the rise, and a maintenance road parallels it.

Like many Adirondack communities, the population of North Creek has grown only slightly over the past century. The region remains a popular tourist destination for its scenic beauty, but its remoteness, rugged terrain, contentious weather, and poor farming soils have thwarted economic growth. North Creek, however, is being revitalized. The popular Tannery Pond Community Center, which showcases the arts, opened in 2002. New shops and restaurants followed. The railroad, guided whitewater rafting, and the annual Whitewater Derby paddling races attract the adventurous.

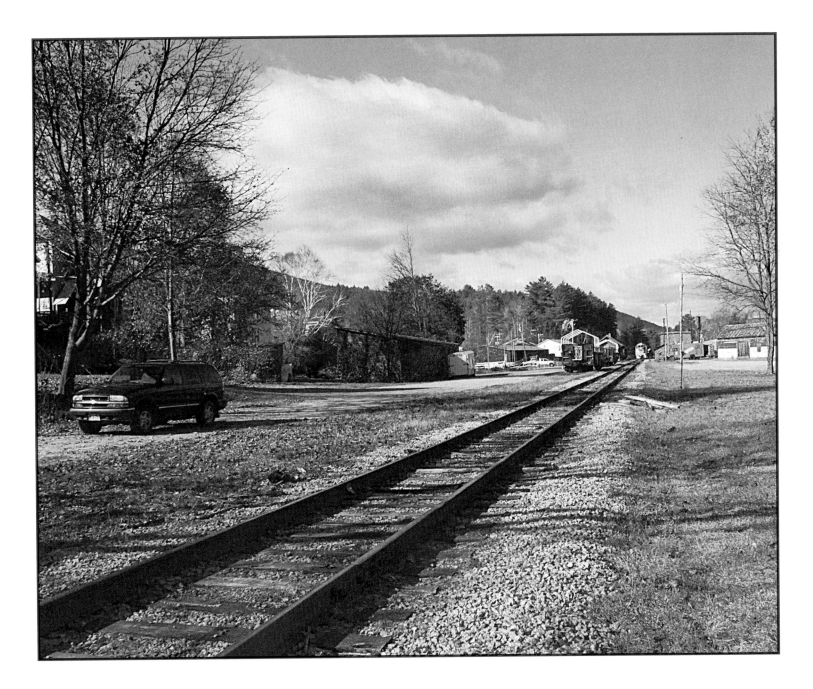

Frontispiece, *Through the Lake Country of the Adirondacks*, 1888

Central Lake Country

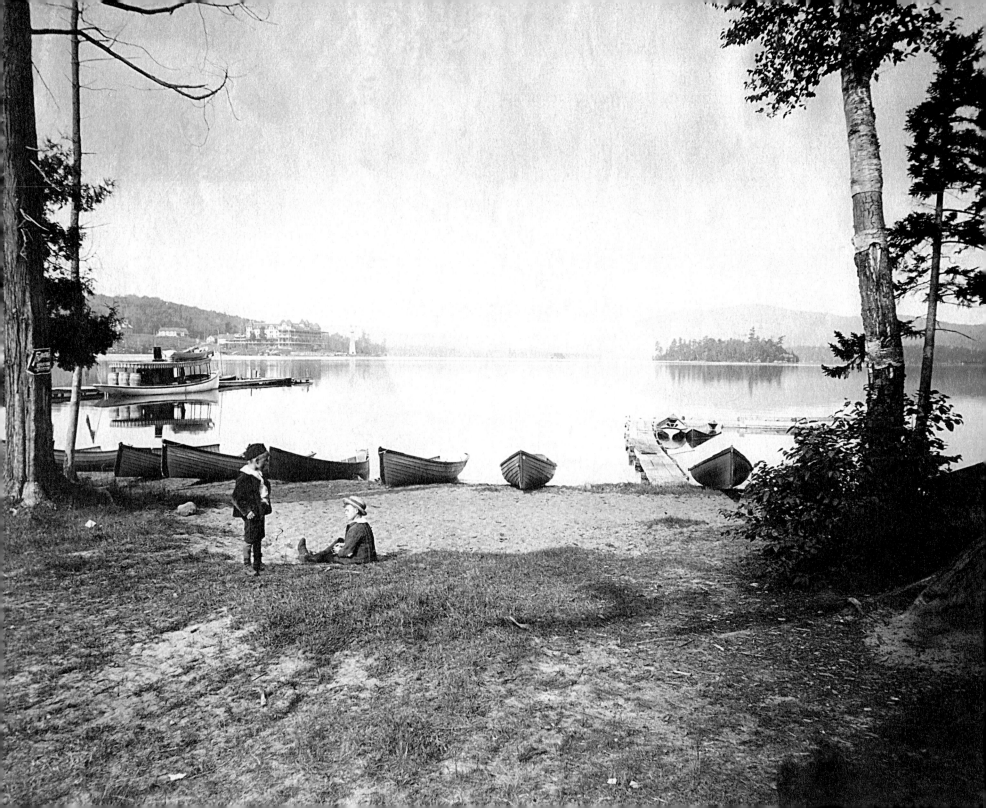

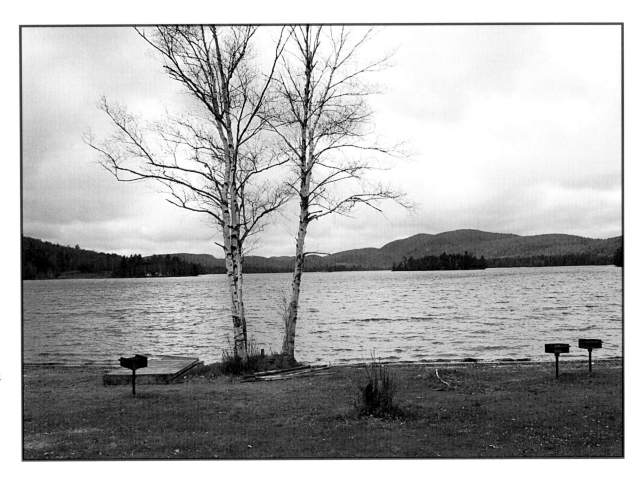

◀ Blue Mountain Lake
from Lake House
1890

As in Stoddard's era, a beautiful sand beach on the east shore of Blue Mountain Lake greets visitors with wonderful views of the islands. The lake was a bustling place at the turn of the twentieth century, much more so than it is today. Several large hotels dotted its shores: the Holland House; the Blue Mountain Lake House; Lake View House; Osprey House; Ordway House, also known as the American Hotel; and the grandest of all, the Prospect House. Most were short-lived; many were destroyed by fire. There are no large hotels on the lake today.

Several steamboats ferried guests around the lake. The Steamboat Landing, out of sight to the right of our positions, was a mooring and dock house. According to current owner Ernie LaPrairie, the original iron rails used to move the boats into dry dock still lead from the lake into the building.

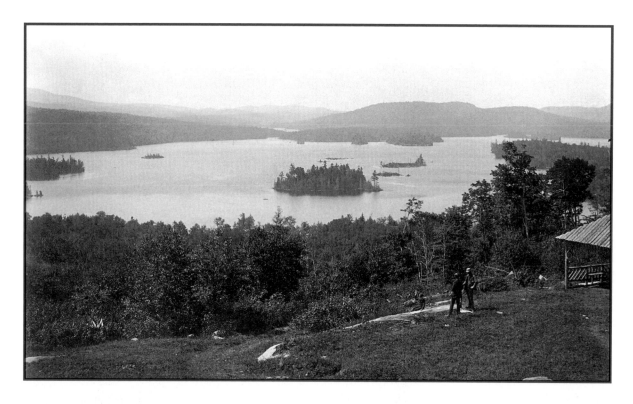

Stoddard photographed this overview of the lake from a hilltop lodge called the Merwin House. I shot it from the walkway leading to the Adirondack Museum cafeteria.

According to an 1889 advertisement for the Merwin House, "The climate is invigorating and, owing to its elevation and bracing air the place is well adapted to those afflicted with hay fever, as many can testify. Sufferers here find instant relief on arrival, while those who come in advance of its anticipated attack are not troubled with it at all during their stay."

As a direct result of the protections granted under the 1894 "forever wild" clause to the state constitution, many places look wilder and more pristine today than when Stoddard photographed them, including the islands of Blue Mountain Lake. Once deforested, several are now thickly wooded. They will remain wild; cutting wood or building on them is prohibited.

Early photographs of the Adirondacks often look ragged: trees are freshly cut, stumps poke out of brushy ground. Homes and communities were literally sculpted out of virgin forest. The landscape is unpolished, not yet manicured to a park-like setting. That would come with time.

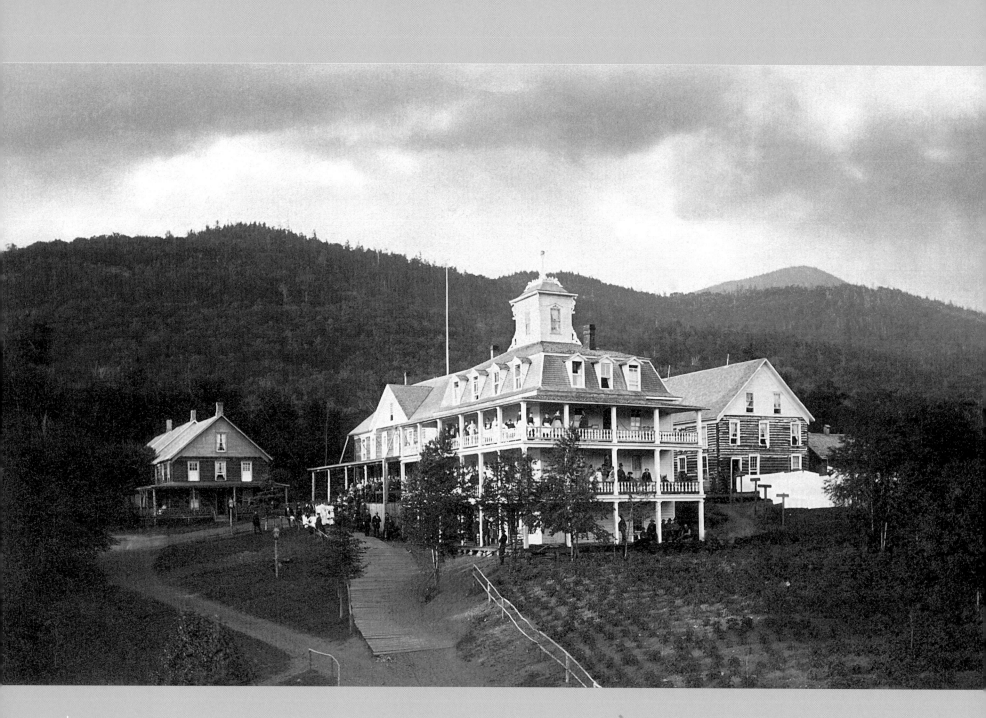

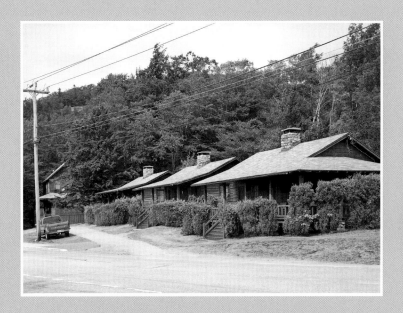

Stoddard's image of Holland's Blue Mountain Lake House shows the second and grander version of the hotel (the original Holland House was destroyed by fire in 1886) and showcases his photographic acumen. The road leads the viewer's eye to the hotel, presented in dramatic perspective. The architectural lines are rendered straight and true by good view-camera technique. Guests dressed in Victorian wear line the balconies, the women in long dresses and skirts, the men in suits and ties, most with hats. Adirondack vacationers tend to dress somewhat less formally today. Stoddard was certainly persuasive, even masterful, at posing large groups; imagine the logistical coordination.

In stark contrast to the rusticity of nearby settlers' homes, the Victorian hotels were opulent. Building and servicing them required architects, drafts people, woodworkers, painters, plumbers, waiters, maids, and cooks. A lumber mill was needed nearby, as were homes to house the many workers. Raw materials were harvested locally when possible, or at further expense, brought in by rail, boat, or wagon; there were no trucks yet, no bulldozers, electric saws, or pneumatic drills. Construction was done mainly with hand tools.

This hotel burned in 1904. Later, Potters Resort motel units occupied the site on the east side of Routes 28N/30. Potter's Restaurant was across the street on the lakefront. Since my initial re-creation in 2002, a private owner purchased the sites, demolished the motel units, and converted the restaurant into a home. Where once stood a grand hotel that beckoned adventurers to the wild lake country, today's cleared lot divulges no hint of its storied past.

◀ BLUE MOUNTAIN LAKE HOUSE
Blue Mountain Lake
1889

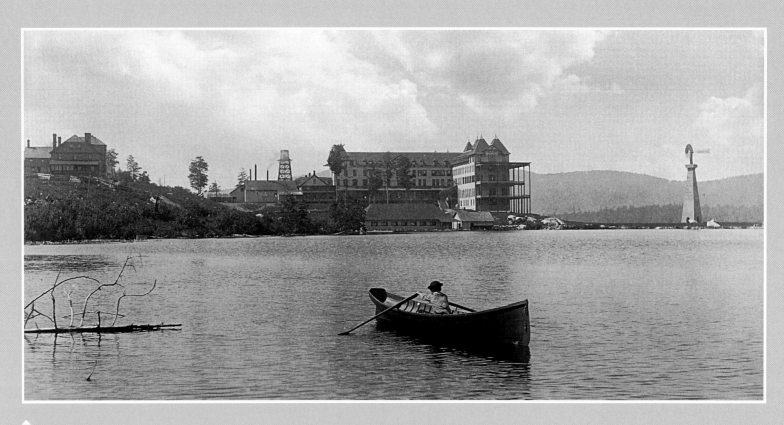

Frederic Durant, nephew of the railroad tycoon, Dr. Thomas Durant, opened the Prospect House on the west shore of Blue Mountain Lake in 1882, at the dawn of the Electrical Age. It was a six-story engineering marvel with three hundred rooms and the latest amenities: steam heat, hydraulic steam elevator, telegraph office, bowling alley, shooting gallery, barber shop, and even a two-story outhouse. With installation overseen by Thomas Edison, this was the first hotel in the world with electric lights in every guest room. It had its own water tower and a windmill to generate power.

Stoddard photographed the sprawling structure from many angles: from the shore, from docks, boats, and even a floating photographic platform (which resembled an oil derrick) in the south bay.

Unfortunately, several circumstances conspired in quick succession against the hotel, and it fell out of favor with the traveling public. In 1892, a rail line was completed between Herkimer and Malone, enabling New Yorkers to reach resorts on the Fulton Chain lakes, Tupper Lake, the Saranacs, and the St. Regis lakes with an easy overnight journey. The Blue Mountain Lake hotels, reachable via a nine-hour bone-rattling stagecoach ride after a long rail

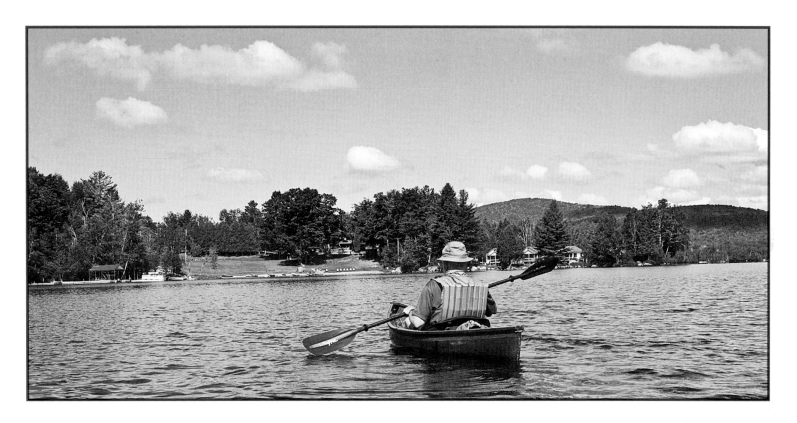

journey, were suddenly perceived as even more remote. There were local outbreaks of typhoid fever. Expenses outpaced revenues, and the Prospect House, once one of the most magnificent resorts in the United States, closed in 1903. It was dismantled in the years of the First World War. The docks, boathouses, water tower, and windmill no longer exist. The charming, though distinctly more modest Prospect Point Cottages now occupy the site at the end of Edison Avenue, still with the world-class views to Blue Mountain.

Of all the Stoddard sites I visited, this location has undergone some of the most shocking changes over time. It is so dramatically different, and yet, to the uninitiated, today's scenery gives no hint of yesteryear's grandeur. The comparison poignantly illustrates the downsizing from the Victorian Age's majestic and graceful architecture to today's more practical building. Aesthetics have taken a back seat to economic realities.

Given modern technological advancements, our perception may be that we build bigger, better, and faster than ever before. But in one Adirondack location after another, I found that the pioneer designers and builders worked on a much grander scale than their modern-day counterparts. And they did it with impressive speed—the Prospect House took only three years from start of construction to opening. What modern buildings lack in stature, one hundred years has made up for in quantity; development has infiltrated the woods.

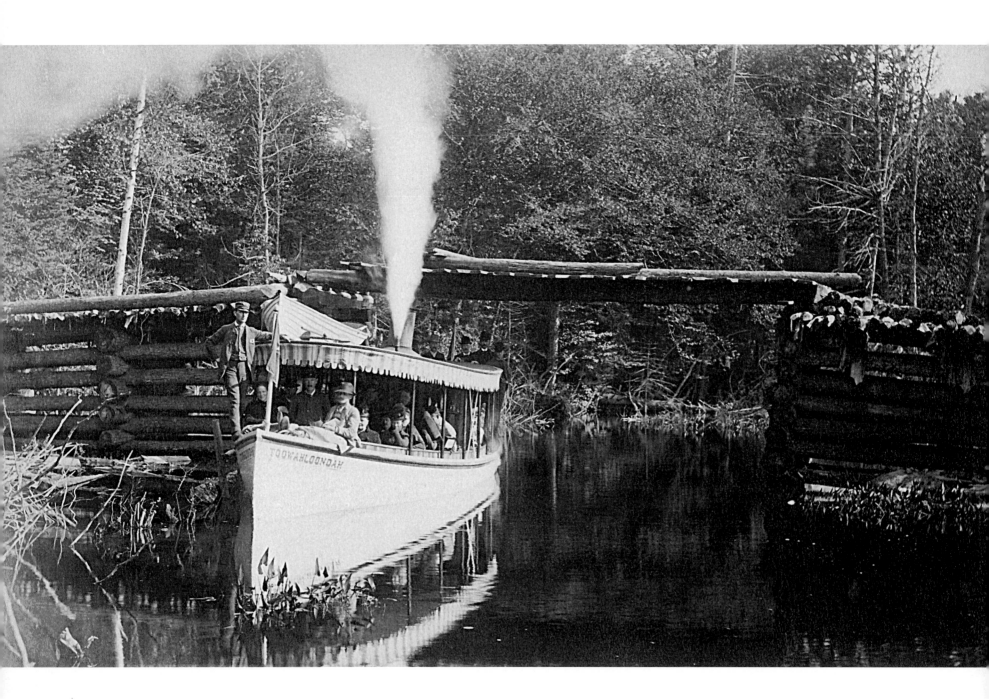

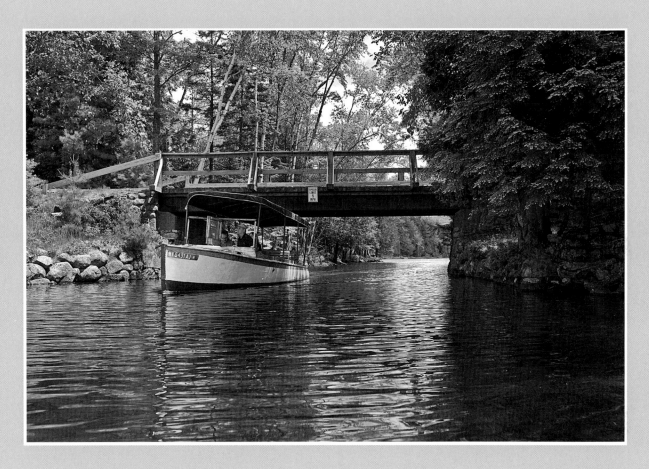

OUTLET BRIDGE
Blue Mountain Lake
1880

The steamboats operating on Blue Mountain Lake in the late nineteenth and early twentieth centuries shuttled supplies and lodgers, and offered sightseeing tours. Stoddard photographed the *Toowahloondah* passing beneath the bridge leading to William West Durant's Eagle Nest property. I photographed the *Osprey*, a circa 1916 mail boat now operated as a tour boat by the Blue Mountain Lake Boat Livery, motoring under the bridge.

Durant built a nine-hole golf course at Eagle Nest, christened in 1900 with a series of exhibition matches featuring golf legend Harry Vardon. Today the property hosts a private artists' retreat—the Blue Mountain Center.

This is the southern bridge of two, separated by an island only several yards wide. It was replaced by a swing bridge, hinged at one end so it could be swung open to allow boats passage. The raised foundation of the bridge ramps is still visible. The other bridge was buttressed with ornate twig scrollwork. Decorative logs support it now.

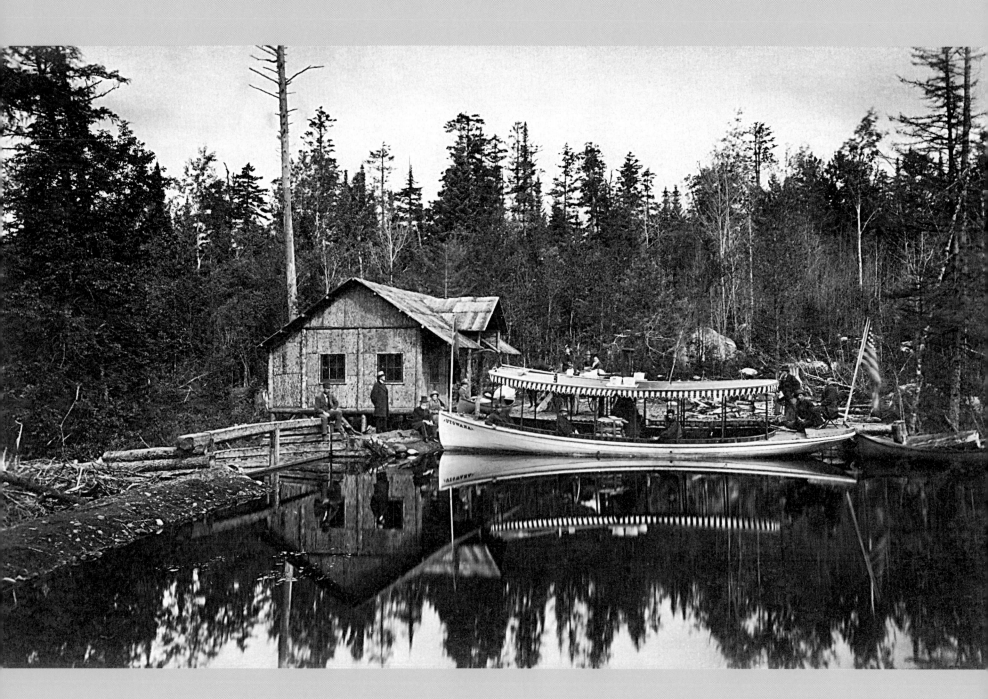

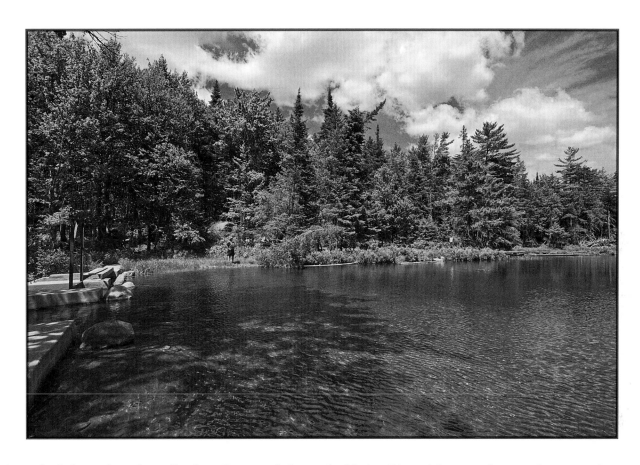

STEAMBOAT LANDING
Utowana Lake
ca. 1880

In the late 1800s, steamboats ferried people and supplies from Raquette Lake up the Marion River. A horse and wagon draw carry then shuttled them around an impassable stretch to this landing at the foot of Utowana Lake, where they could catch another steamer to Eagle and Blue Mountain Lakes. An earthen dam increased water depth to make the stream navigable between the lakes.

In 1899, the wealthy landowner and philanthropist William West Durant built a rail line between the Marion River and this landing (the Upper Terminus). The Marion River Carry Railroad was the shortest standard gauge railroad in the world, about three-quarters of a mile long. It had no turn-around; the train simply ran forwards and backwards between the two end points. It operated from 1900 to 1929.

Stoddard photographed the *Towahloondah* docked at the Upper Terminus. There's no steamboat service here any longer, the cabin has vanished, and the dam has been redesigned. But passersby can still see some of the landing dock's wooden supports and maybe sense the key role this place played in the area's rich history of wilderness transportation.

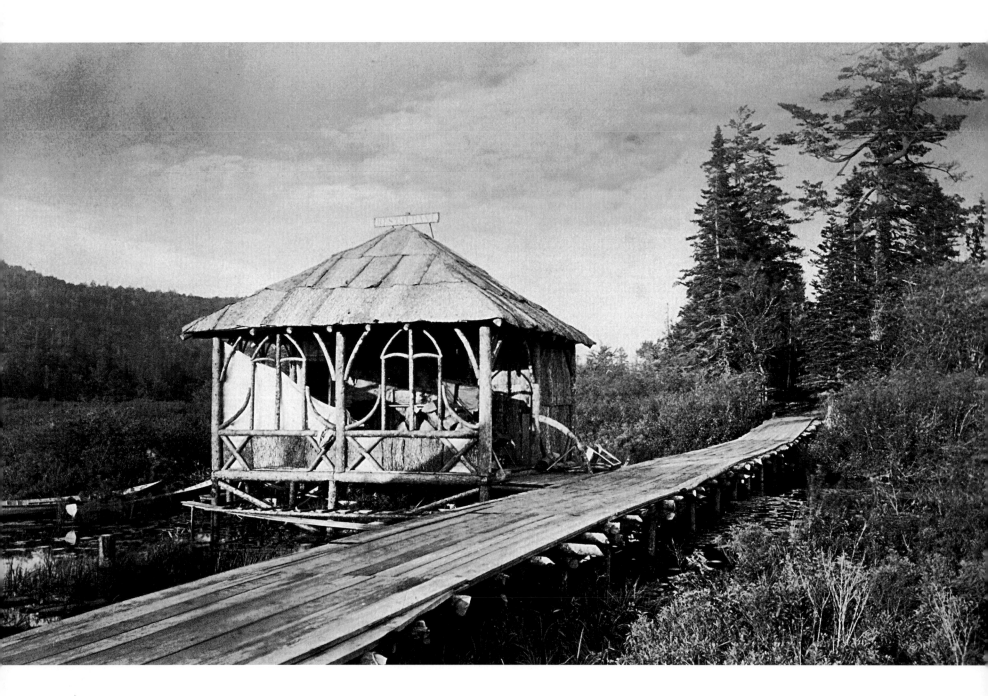

RESTAURANT
Marion River Carry
ca. 1880

Route 28 encroaches within a couple miles of the Marion River for much of its length, but the tranquil marshlands through which the river winds make it feel remote. That someone once operated a restaurant here seems utterly fantastic.

The restaurant catered to steamship passengers traveling between Raquette and Blue Mountain Lakes. It pre-dates the Marion River Carry Railroad. Once the rail line was built, starting here at the so-called Lower Terminus, passengers arriving on a steamer from Raquette Lake would disembark, then board the train to the Upper Terminus at the foot of Utowana Lake, bypassing the remainder of the river and the draw carry, to catch another steamboat heading to Blue Mountain Lake.

The train tracks were removed in 1929, rendered obsolete after Route 28 was laid, largely from materials brought in by rail and water. Steamboat service ceased and the landing was dismantled. The train and steamers had, in large measure, worked themselves out of business.

This scene has become my favorite Stoddard re-creation. Along the riverbank, my paddling companion, Adirondack guide Mike Prescott, and I could see the remnants of the landing's support pilings. He described how a short loop was dredged here so the steamers wouldn't have to turn around. They could pull alongside the dock, disgorge passengers and materials, then swing around and head back downriver.

We beached our boats and walked ashore to a small grassy clearing, pinpointing the former site of the restaurant. The scene was enchanting; we could trace the path of the old plank walkway through the same swath cut through the grove of hemlocks that once led to the rail terminal.

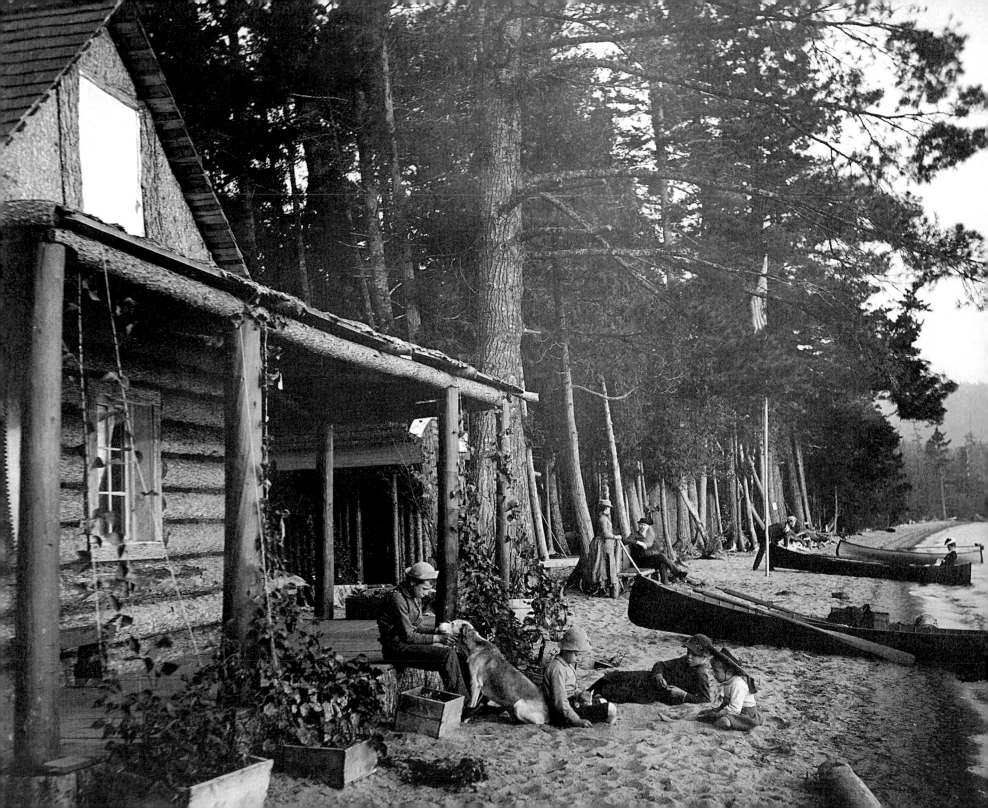

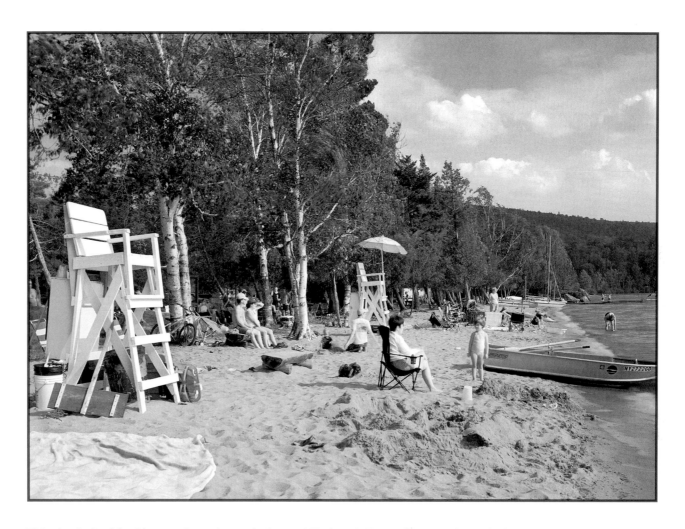

◀ HATHORN'S
Raquette Lake
1888

This classic Stoddard image of vacationers in front of Hathorn's Forest Cottages shows the long stretch of sand beach on the southeast shore of Raquette Lake, one of the most beautiful beaches in the Adirondacks. The state of New York opened it to the public as Golden Beach State Campground in 1931.

Upon close inspection, our two images are eerily alike, with several similar objects in nearly the same positions, 114 years apart. Boats are pulled up on shore; children play in the sand; adults relax on benches. Shoreline trees shield the campground from winds blowing off the lake.

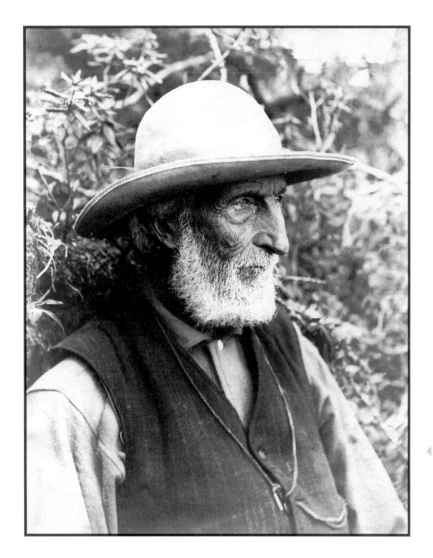

Stoddard employed a documentary style in photographing Adirondackers in their realm. He was especially fond of guides; many of them were true characters, like the wizened Alva Dunning, who lived from 1816 to 1902.

Alvah was known as the Hermit Guide of Raquette Lake. He was a simple man who searched for seclusion and privacy throughout his life. Alvah joined his father hunting and trapping at age six, and by the time he was twelve, he was guiding men into the Raquette Lake area. His reputation as an expert woodsman and skilled hunter made him one of the most sought-after guides of his time. Sportsmen traveled great distances to be led by this legendary figure.

◄ ALVA DUNNING
Adirondack Guide
date unknown

Before the turn of the twentieth century, most Adirondack guides worked out of resort hotels on the major lakes, including Long Lake, Blue Mountain Lake, the Saranacs, and St. Regis Lake. Dunning was an independent. The alliances with hotels have largely vanished. Today, many guides work through local outfitters offering canoeing, camping, and fishing expeditions to city "sports."

Griz Caudle is a throwback to the old-time guides, with a passion for life on the water and the sharing of local knowledge with out-of-town clients. He guides for St. Regis Canoe Outfitters out of Saranac Lake.

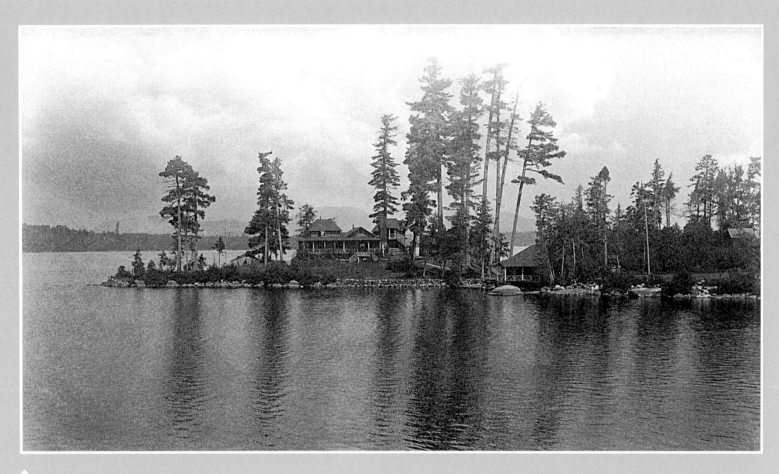

CAMP OF
CHARLES DURANT
Raquette Lake
ca. 1885

Osprey Island is an elongate, natural spring-fed gem in the middle of Raquette Lake—with a controversial past. It was originally known as Murray's Island, after the Reverend William "Adirondack" Murray, who stayed here during the summers of 1867–69. Here he wrote his famous book, *Adventures in the Wilderness*, which enticed droves of tourists to the region.

When he left, the guide and hermit, Alvah Dunning, took possession of Murray's camp, calling it home for ten years. After Dr. Thomas Durant was legally granted Raquette Lake area lands, including Osprey, he decided to sell the island to his nephew, Charles, but Alvah was determined to stay put, contending that Murray had given him the island. A heated argument ensued; he and Charles nearly came to blows and threatened gunfire. In an act of benevolence, Thomas' mother invited Alvah to dinner. He went, was treated kindly, and agreed to sell the

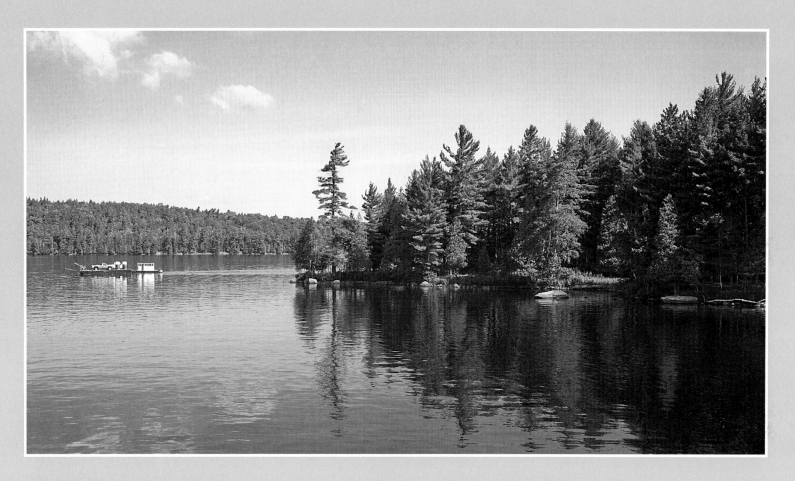

island to the Durants, reportedly for one hundred dollars. When later asked about the sale, Dunning replied, "Ol' Alvah can be coaxed, but he can't be druv."

Charles erected Camp Fairview here. It went through several iterations, including the addition of the twin towers seen in Stoddard's image, photographed from Church Island. Charles eventually sold the island to another party, but the State of New York claimed ownership, and legal ranglings kept possession in limbo for many years. The main lodge burned down around 1922. Osprey's trees have filled in over time, enveloping the smaller cabins beneath them, now part of a private camp.

As I photographed the scene, a ferry carrying a vehicle cruised across the lake, a reminder of the days when lakefront camps far from train and stage routes were serviced by boat.

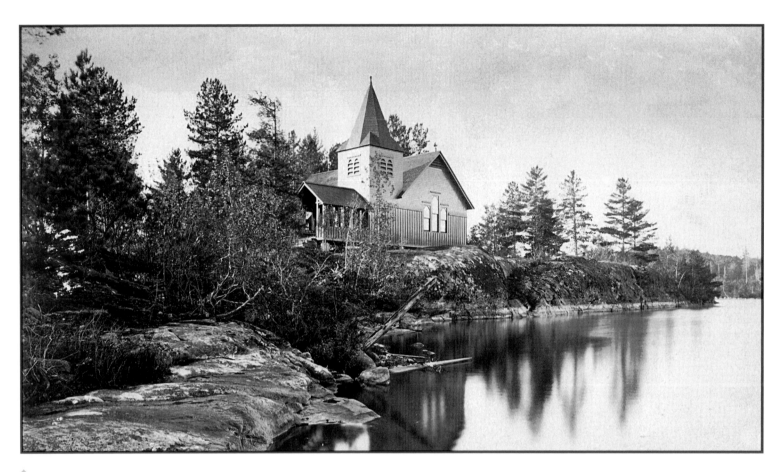

ISLAND CHURCH
Raquette Lake
ca. 1885

W.W. Durant built the Episcopal Mission of the Good Shepherd on St. Hubert's Isle in 1880. Ten years later, he added St. Williams Roman Catholic Church on nearby Long Point.

The Episcopal Church's bells were rung to herald the worship service. Aquatic buses resembling extended guideboats, so-called church boats, were dispatched to collect churchgoers from their docks and shuttle them to the island. Some went in their own boats.

There's a certain romantic appeal to going to church on an island or peninsula reachable only by boat. Historian Alfred Donaldson wrote of the island church: "The scene of a bright Sunday morning, when the boats gathered from far and near, filled with worshippers in gay apparel, was highly picturesque and gave church-going the novel charm

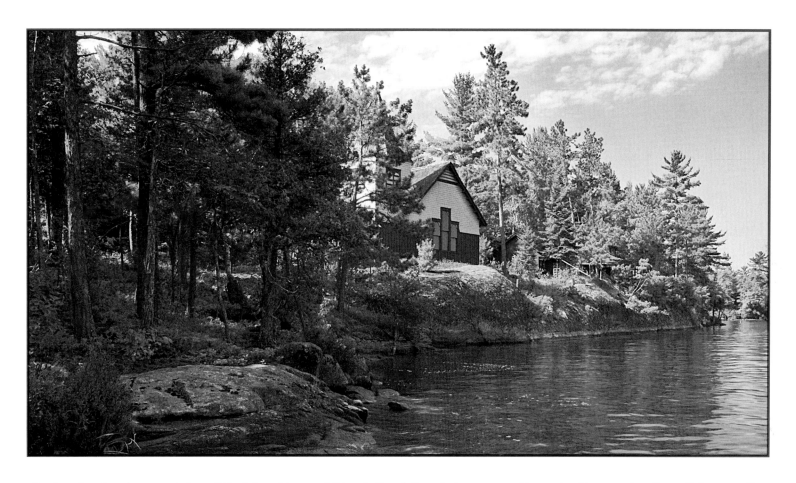

of a devotional outing to a shrine of God-tinged beauty." It's a fading Adirondack custom, still practiced here and on Long Point, as well as on Chapel Island in Upper Saranac Lake and at the Needles Eye Chapel on Hecker Island in Lake George.

The sanctuary is virtually unchanged in outward appearance since Stoddard photographed it. It sits atop a rocky ledge with a commanding view to Osprey Island, a stone's throw to the north. The surrounding pines have matured, but my fellow paddlers and I could distinguish the same shoreline outcrops Stoddard saw.

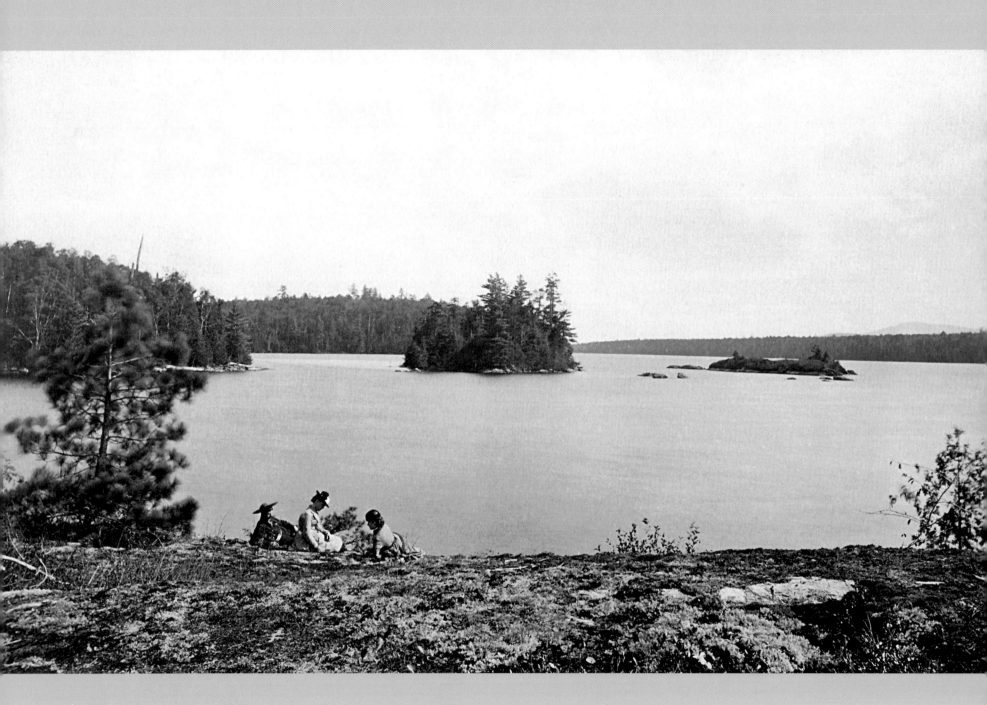

RAQUETTE LAKE
EAST BAY
from St. Hubert's Isle
ca. 1880

Stoddard posed three people relaxing at East Bay on the east side of the island. We can see parts of Osprey Island and Woods Point on the left, and Long Point on the right. Following Stoddard's lead, I posed with my paddling partners, Mike Prescott and Rick Rosen. Just yards away, boat slips once tethered churchgoers' boats, and a wooden walkway aided the traverse across shoreline rocks.

The two smaller islands, called Wee Two, were apparently unoccupied when Stoddard photographed them. Today, each hosts camps, partially hidden beneath towering white pines.

In the late nineteenth century, steamships operated on Raquette Lake on posted schedules, two to four times per day, ferrying passengers and servicing camps. Today, the double-decker *W.W. Durant* provides sightseeing excursions and dinner cruises in summer.

BUTTERMILK FALLS
Raquette River
ca. 1880

Stoddard used a long exposure to create this gossamer blur of Buttermilk Falls on the Raquette River, near Long Lake. I used a two-and-a-half-second exposure. It's interesting to see how the two large boulders to the left of the falls have eroded over one hundred years and what similar courses the water follows over the ledges. Also, note the ragged look of the background trees in his image, likely the result of logging.

Buttermilk is one of the most popular waterfalls in the Adirondacks, a favorite for contemplative relaxation or a refreshing swim. Today, the falls and surrounding lands are protected within the Sargent Ponds Wild Forest.

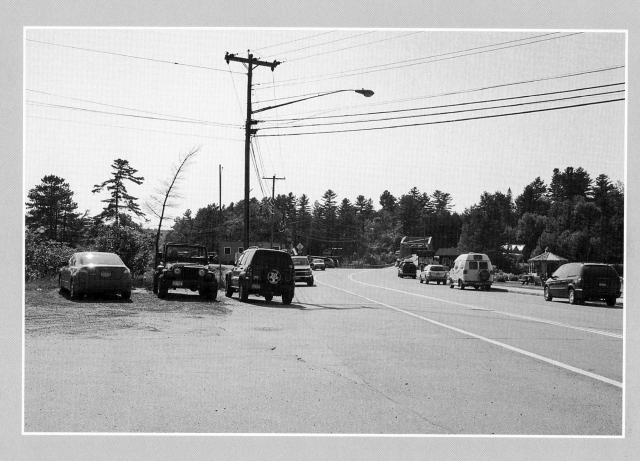

FLOATING BRIDGE
Long Lake
ca. 1880

This may be one of the most difficult re-creations to visualize—and to me, one of the most fascinating—because so much has changed over the last century. In Stoddard's day, a floating bridge spanned Long Lake, which is actually a ponding of the Raquette River. It was laid at the narrowest constriction, about halfway up the fourteen mile-long body, at the hamlet. A raised section allowed small boats to pass beneath. Crossing on horseback or wagon must have been challenging, especially in stormy weather.

For this image, Stoddard faced west, standing on what is now Route 30. That's Pine Island on the left, which separates a backwater lagoon—Park Lake—from Long Lake. In the 1930s, the Civilian Conservation Corps brought in filler to form the roadbed between the east shore and the island. Today's iron bridge spans the lake from the island to the west shore.

Tall pines and an office building occupy the island now. The public beach is across the street. Helm's Aero Service—the floatplane sightseeing firm—is out of view to the right. Route 30 roughly follows the course of the floating bridge back to the east shore. I stood in the parking lot of the landmark Adirondack Hotel, built in 1900, to re-create this view.

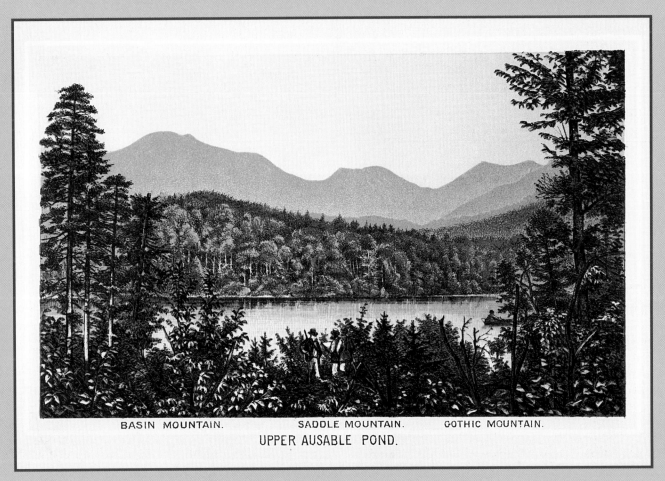

BASIN MOUNTAIN. SADDLE MOUNTAIN. GOTHIC MOUNTAIN.

UPPER AUSABLE POND.

Plate 11, lithograph, Upper Ausable Pond, from *The Adirondacks*, 1878

High Peaks Region

Compiled by
.R. STODDARD,
GLENS FALLS, N.Y.
Sixth (Revised) Edition
1904

In 1877, Stoddard expressed his awe of Roaring Brook Falls, along what is now Route 73 south of Keene Valley, with John Muir-like eloquence: "The water here makes a descent of nearly three hundred feet in a succession of cascades, hardly touching at each step to gather for the next succeeding plunge; then flashing swiftly down the almost perpendicular rock for the last fifty feet, through a trough worn out by its action, to rest at the bottom."

The volume of water leaping over the rocks fluctuates with the seasons. In spring, it flows as a graceful bridal veil. By most summers, it wanes to a trickle. It freezes into a giant column of ice in winter, beckoning climbers.

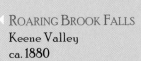
ROARING BROOK FALLS
Keene Valley
ca. 1880

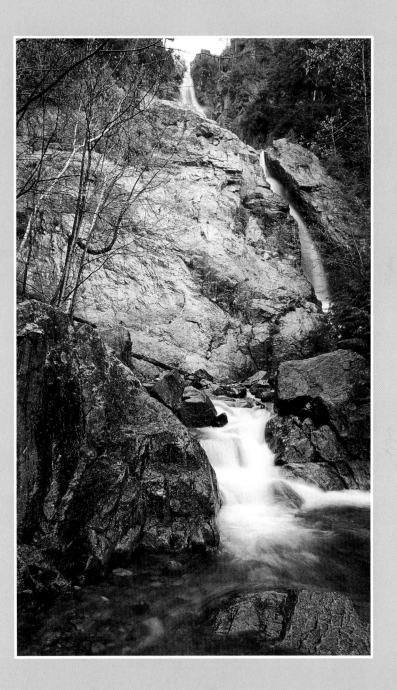

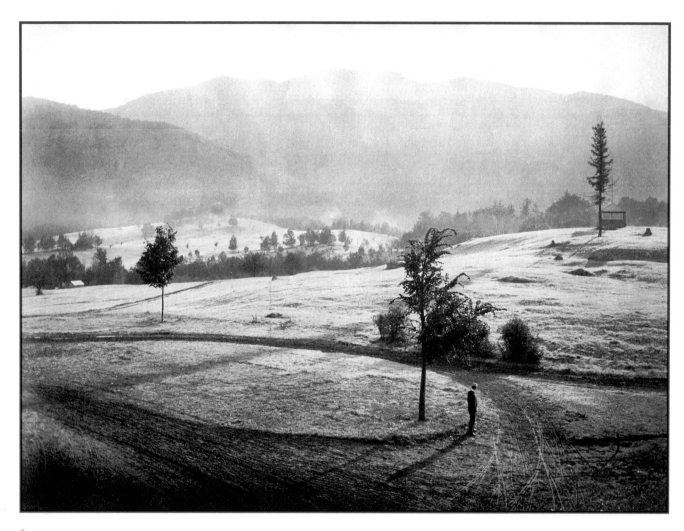

THE GIANT FROM
ST. HUBERT'S INN
Keene Valley
1891

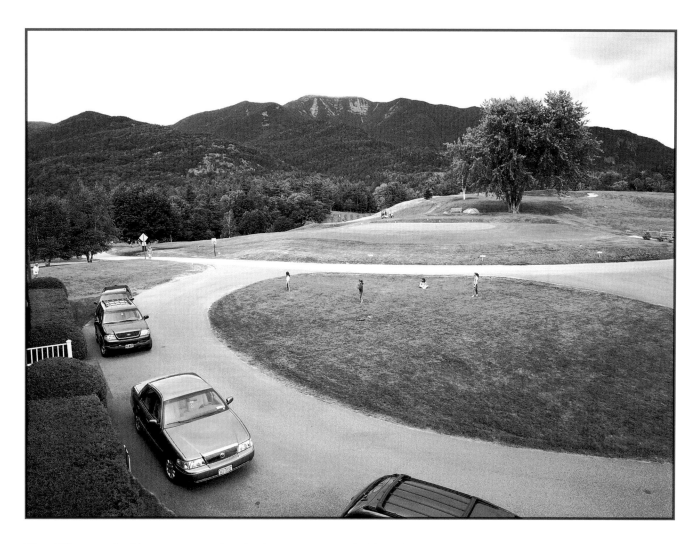

The differences in this scene over a hundred years are remarkably slight, thanks in part to the stewardship of the Ausable Club. The humped profile of Giant Mountain endures, as do its landslide scars. The Club's golf course keeps the rolling hills open. The trees have grown significantly since the 1880s, but you can still see some of the same boulders pockmarking the course. Even the circular driveway of the club closely traces its original path.

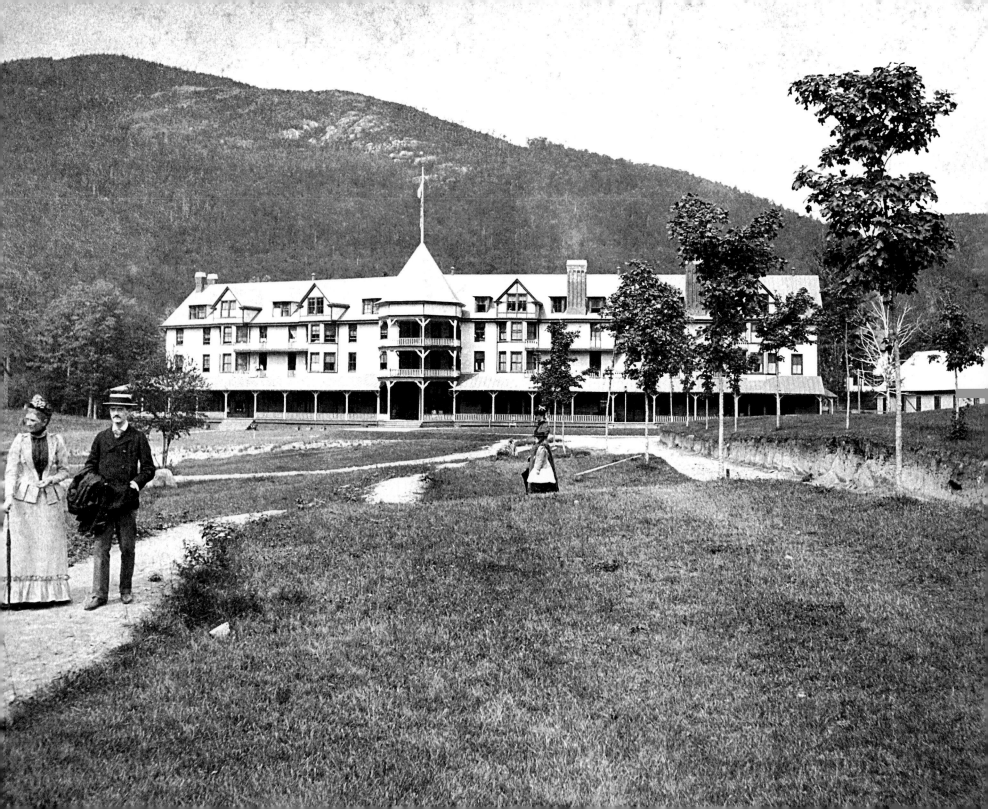

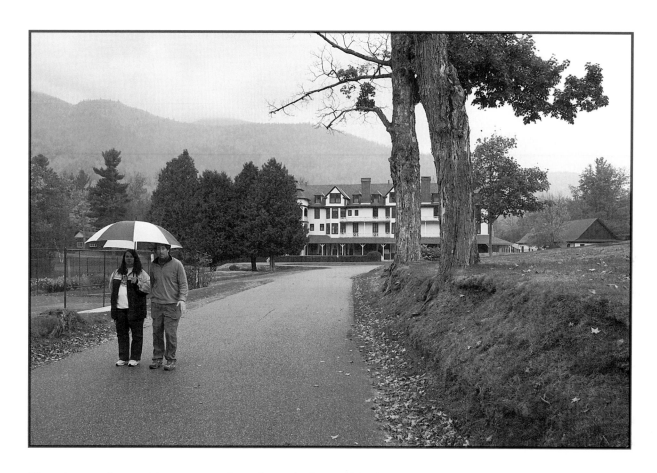

◄ St. Hubert's Inn
from the East
Keene Valley
ca. 1891

Though now obscured by mature cedars, the majestic Ausable Club lodge retains its original grandeur. Built in 1890 as the St. Hubert's Inn, it was designed to offer scenic views from its perch above the Keene and Ausable valleys. For alignment, note the two chimneys and the semi-circular, multi-story porch.

The club is a private members-only organization. Its immaculate grounds include walking paths, tennis courts, the golf course, and member-owned lodges. The club permits hikers to walk the paved road to the Ausable Lakes to access High Peaks trails.

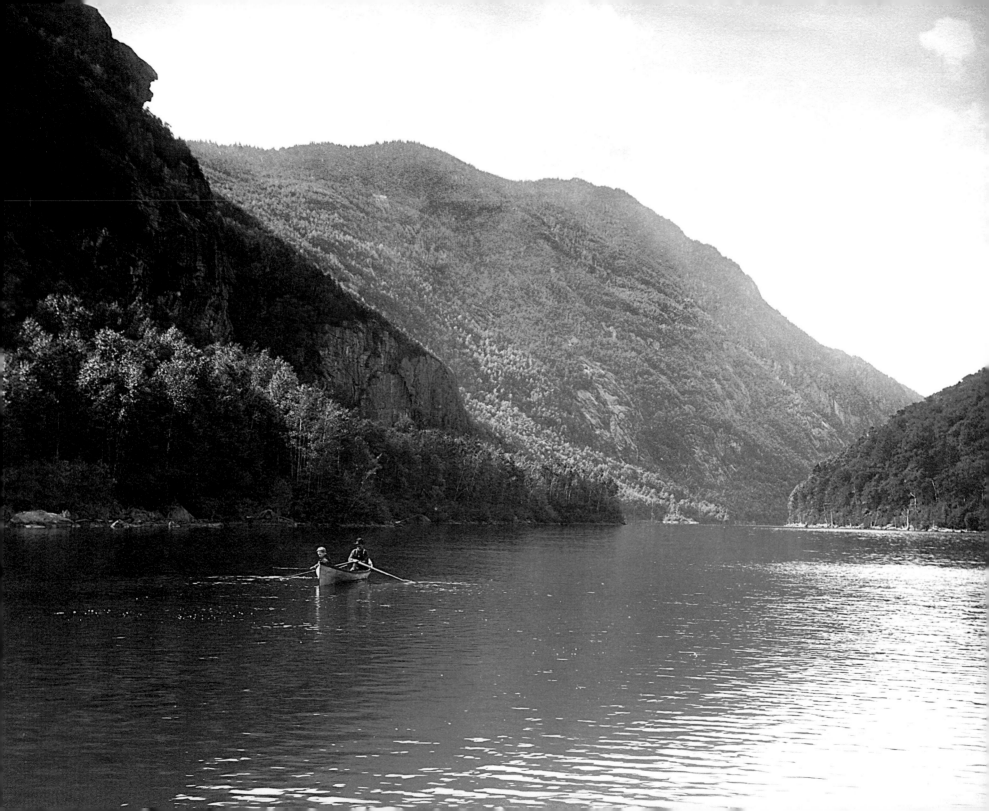

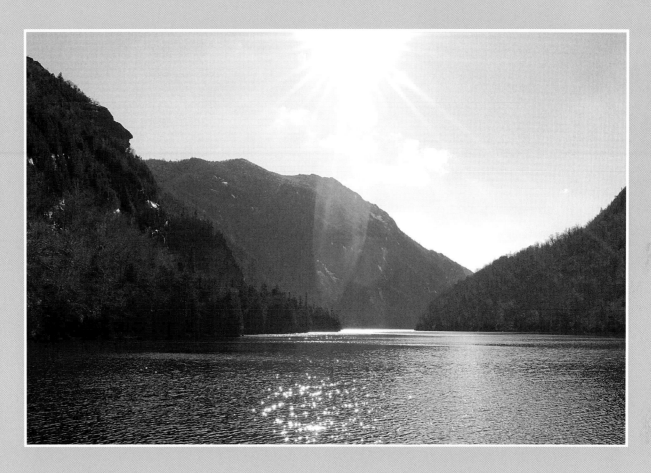

INDIAN FACE
Lower Ausable Lake
ca. 1891

The three-and-a-half-mile hike along Gill Brook to Lower Ausable Lake was the longest trek I made to rephotograph a Stoddard scene and one of the most gratifying. I went in November, with Adirondack guide "Griz" Caudle and his wife, Deborah, following almost the same route Stoddard had taken with his guide, Mountain Phelps, many decades earlier. The brook, rarely more than a few inches deep, coursed over brightly colored anorthosite cobbles. In several places, we saw trout swimming in pools beneath a thin glaze of ice. At the Flume, where the brook plunges through a narrow chasm into a crystalline pool, two mink chased trout in circles, fishing for a meal. It is because this land has been formally protected from development that this wild scene could play out before us. We found the Ausable Lakes looking as untamed and scenic as they do in Stoddard's photographs.

Seneca Ray used a guideboat to shuttle himself around the lakes to photograph magnificent mountain views. He photographed this guideboat beneath the distinctive, sheer cliffs of Indian Face. He also lugged his camera up the mountain.

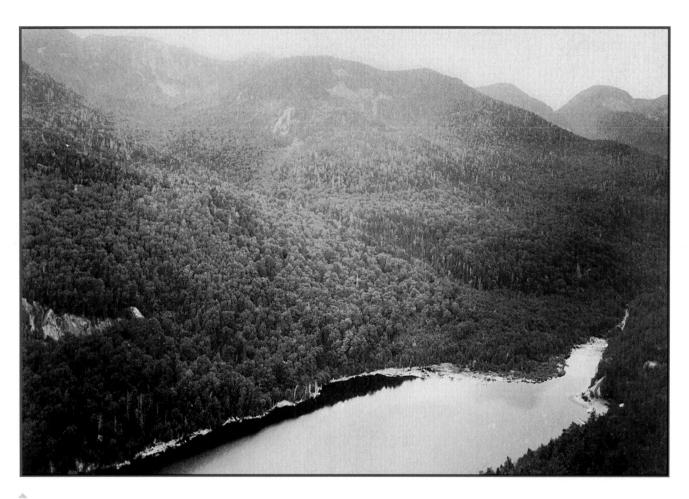

LOWER AUSABLE LAKE
from Indian Head
ca. 1891

The ramparts of Gothics, Armstrong, and the Wolf Jaws tower over the outlet of Lower Ausable Lake. Protected within the High Peaks Wilderness Area, the wild character of these forested slopes remains much as it was in Stoddard's time. Even the landslide scar patterns are remarkably similar.

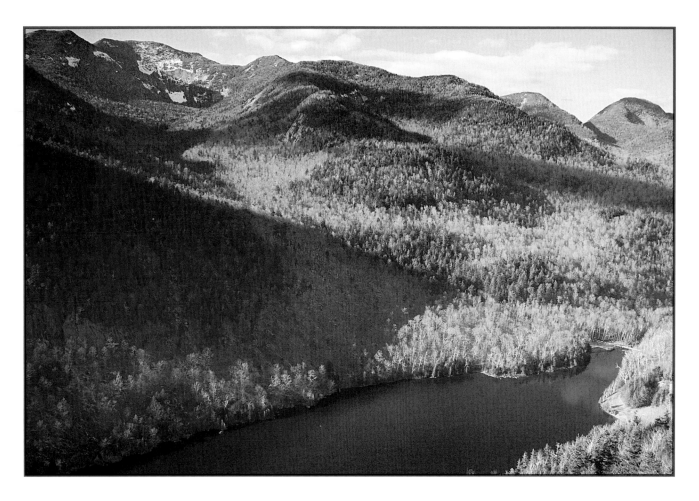

One of the most beautiful waterfalls in the region—one hundred fifty-foot Rainbow Falls—is hidden in the foliage about a quarter-mile left of the outlet. On the near side, you can see the road leading to the cottage where Stoddard borrowed a guideboat. That building is gone, and a new cottage and boathouse now sit at water's edge.

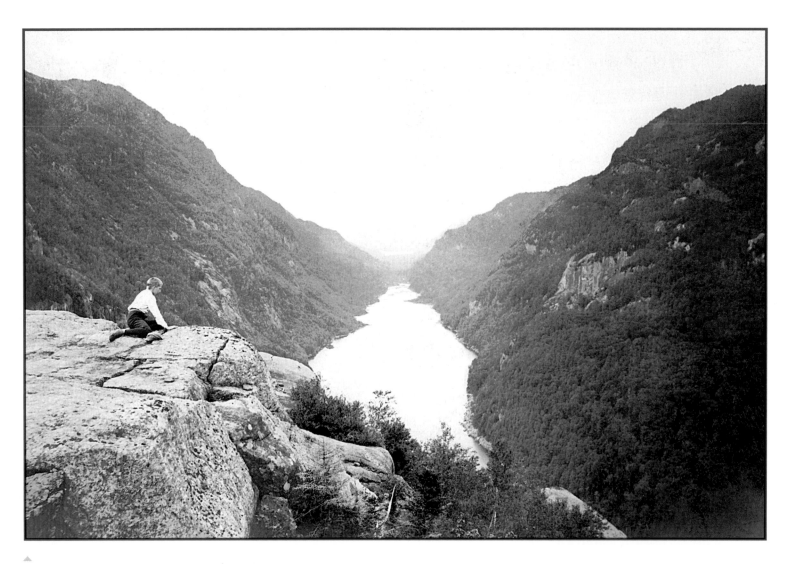

LOWER AUSABLE LAKE
from Indian Head
ca. 1891

Atop Indian Head, seven hundred and fifty feet above Lower Ausable Lake, Griz posed atop the same promontory as Stoddard's model. This iconic overview of the Ausables, which occupy a narrow fault valley between the Colvin and Great Ranges, has changed little over time.

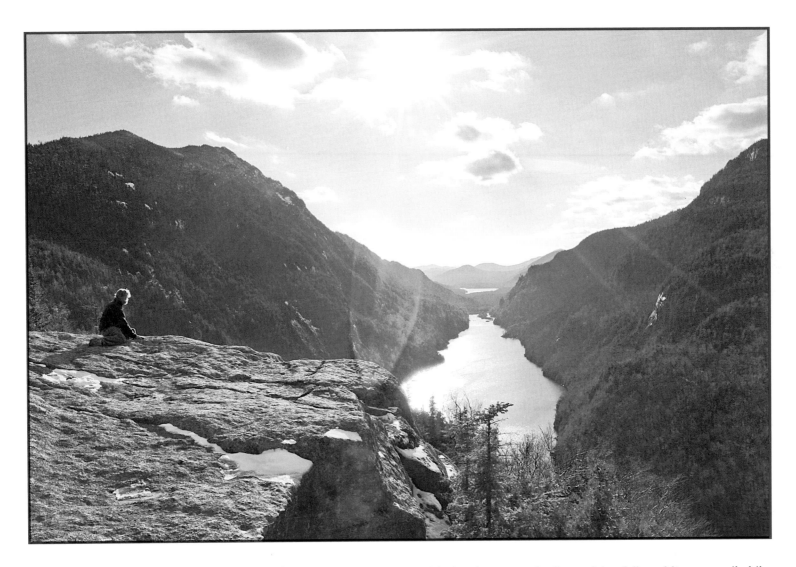

There are some private cottages on the shores of the Upper lake, accessed by boating across the Lower lake, followed by a one-mile hike between lakes, and another boat ride. In 2007, the Ausable Club celebrated the one-hundredth anniversary of the first cottages built on these shores. They post-date Stoddard's visit.

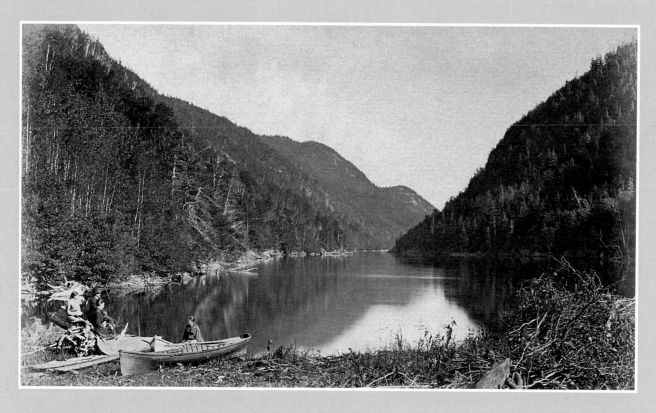

People posed with a guideboat at the west end of Edmonds Pond, now called Lower Cascade Lake. They're on a thin spit of land deposited by an ancient landslide that divides the Lower and Upper Lakes. In Stoddard's time, a lodge called Cascade House was wedged between the cliffs of Cascade Mountain and the lakes.

No road is visible in Stoddard's image. A dirt stagecoach trail, hidden by the woods on the left, was the predecessor of today's Route 73. Arguably the most scenic roadway in the Park, it winds along the northern edges of both lakes. It's visible in the distance in my image.

According to an 1889 advertisement, Cascade House was located on "One of the most attractive spots, and the finest fishing grounds in the Adirondacks. It is 2,200 feet above tide water and the coolest location in the mountains. The house is provided with fireplaces, excellent table and comfortable beds. Also tennis court, croquet ground, and bowling alley."

"The coolest location in the mountains" is hardly an exaggeration. Bitter cold descends on the fault valley in winter, freezing the lakes clear as glass. Attracted by the ice and sheer beauty, Dorothy Hamill filmed a skating special for television here.

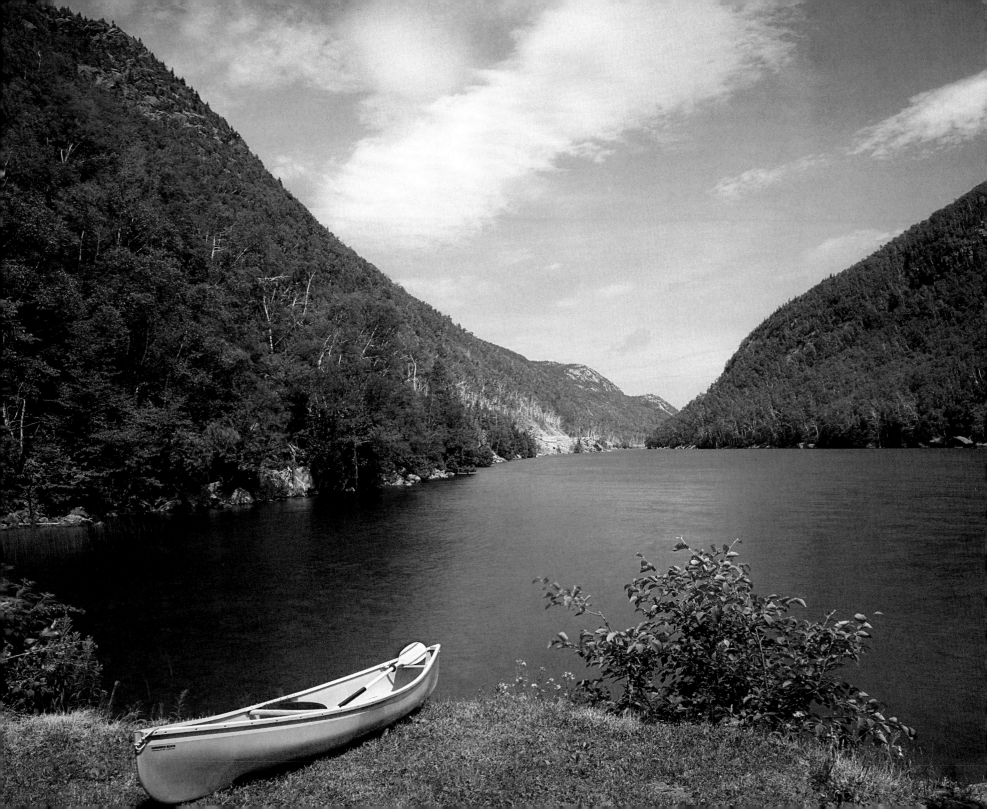

INDIAN PASS
from Lake Henderson
ca. 1890

I didn't re-create this Stoddard image on purpose. I encountered it while browsing the Chapman Museum's computer database of Stoddard's works and realized I had paddled this area over a year earlier. Our pictures align amazingly well, though I photographed mine from a canoe. Indian Pass lies in the background, between the rocky cliffs of Wallface Mountain and the flanks of the MacIntyre Mountains.

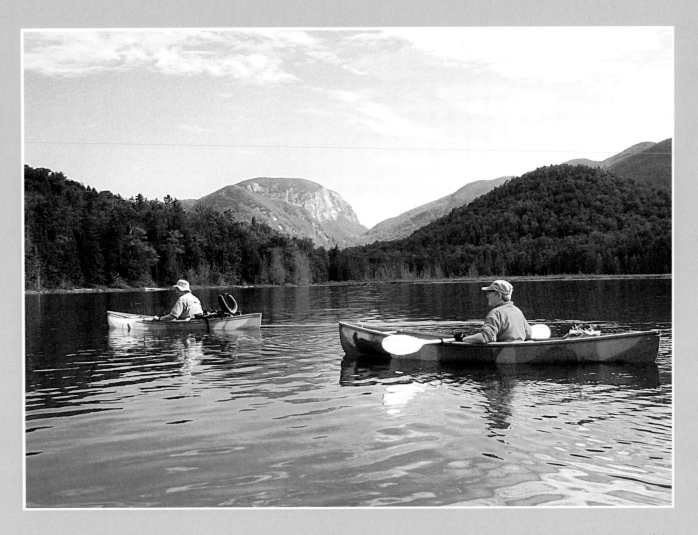

You can readily distinguish the previous shoreline in Stoddard's view. Loggers likely breached the dam at the head of the lake to float logs to mill, temporarily draining the lake to a puddle. Now called Henderson Lake, it is the gateway to lands surrounding the Preston Ponds and Duck Hole, currently in the process of being added to the Forest Preserve. Each is a wild alpine gem with spectacular views of the High Peaks.

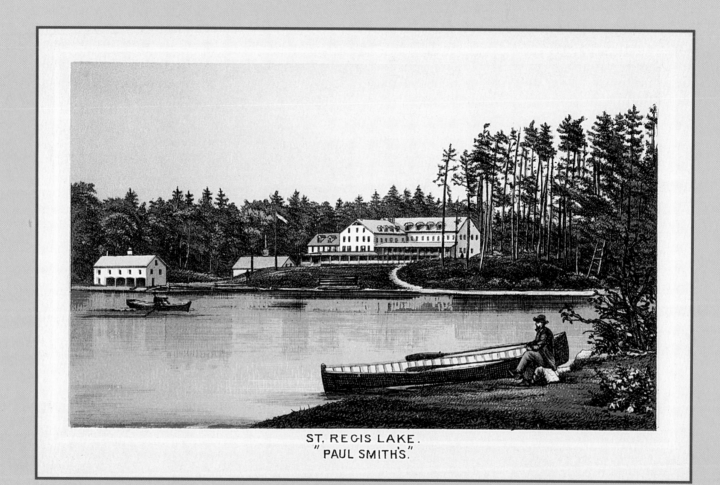

ST. REGIS LAKE.
"PAUL SMITH'S."

Plate 16, lithograph, St. Regis Lake, from *The Adirondacks*, 1878

Northern Adirondacks

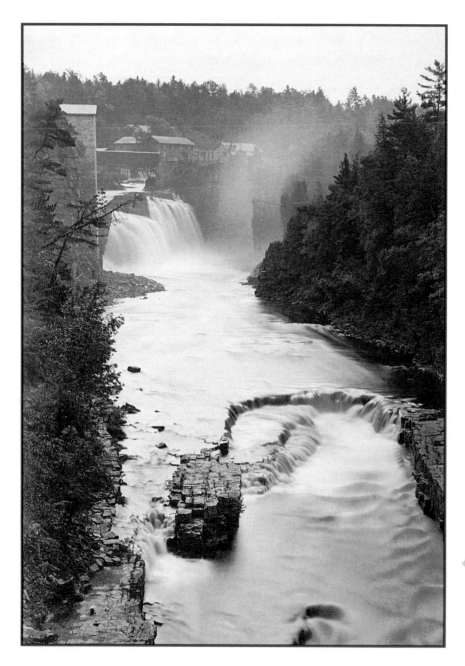

In 1765, Europeans discovered Ausable Chasm, where they found Atlantic salmon spawning in great numbers. Saw mills, grist mills, paper mills, and wheelwright shops were soon built, powered by the Ausable River's strong currents. Iron ore deposits were discovered in the Adirondacks, and in 1876, the AuSable Chasm Horsenail Works began producing two tons of iron nails each day. Water from the falls fell through an upright tube—four feet in diameter and fifty-three feet high—to power a water wheel that produced one hundred horsepower. The nail works closed in the 1890s, but the Chasm has prospered as a tourist attraction, celebrating its 138th anniversary in 2008.

◀ Birmingham & Horseshoe Falls
Ausable Chasm
ca. 1879

Stoddard photographed this scene from a clearing on the west rim. I replicated his shot from a nearby wooden viewing platform along the Rim Walk. Birmingham Falls (now called Rainbow Falls) consists of the two ledgy cascades in the background. The tall waterfall in the back right of my image is actually overflow from a powerhouse. The building on the right is a hydroplant. My image also includes the most dramatic change to the attraction since Stoddard's day: the Route 9 bridge spanning the chasm, built in 1925, linking points south with Plattsburgh. Horseshoe Falls lies beneath the bridge.

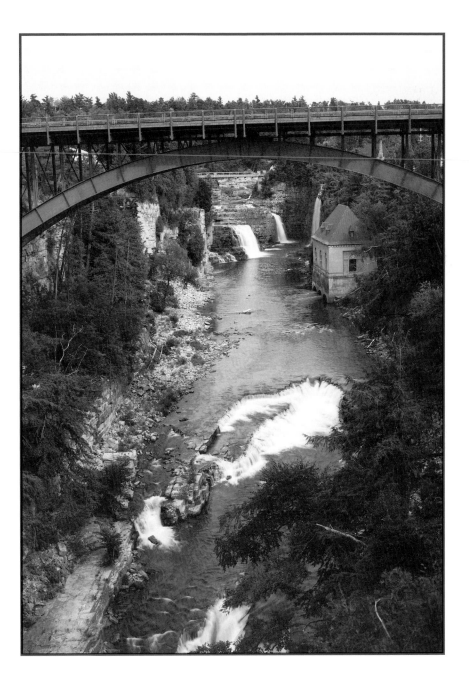

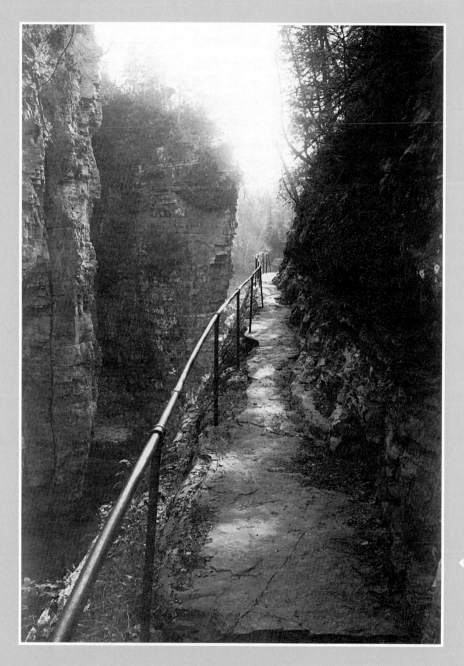

Carved through Potsdam Sandstone, Ausable Chasm is about two miles long and up to two hundred feet deep. Geologic processes alter it slowly, inexorably, yet sometimes catastrophically. Ravaging floodwaters roared through the chasm on January 19, 1996, when temperatures rose from twenty degrees to seventy-five degrees in twelve hours, quickly melting several feet of snowpack in the mountains and eighteen inches on the ground locally. In what was deemed a one-hundred-year event, the waters swept away bridges, staircases, and trails. New and stronger facilities were built in time for the summer tourist season, but after abnormally heavy rains, floodwaters struck again less than ten

◀ THE LONG GALLERY
Ausable Chasm
ca. 1879

months later, on November 9, again washing out bridges and staircases. New bridges and trails have since been installed.

As my guide and I descended into the chasm, I felt as if I were drifting back in time. The walls seemed to move closer, and I strongly sensed Stoddard's presence. In the Long Gallery, we pinpointed the great columns, cascades, and footpaths he had photographed. We observed the same fractures in the chasm walls and even the distinctive stair-step pattern he saw on the cliffside pathway.

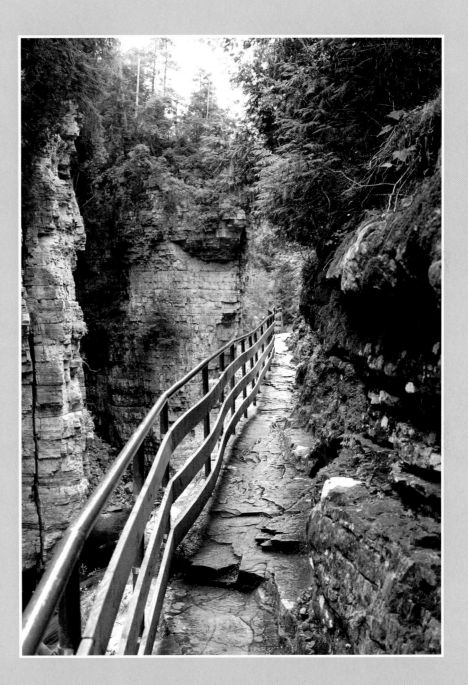

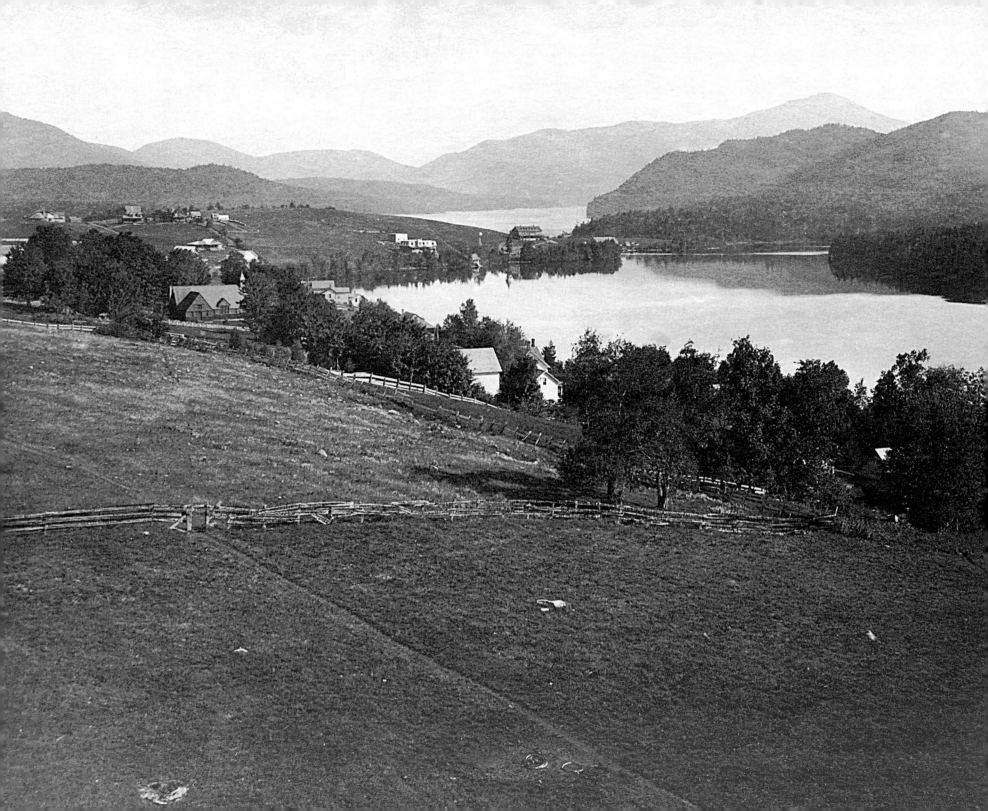

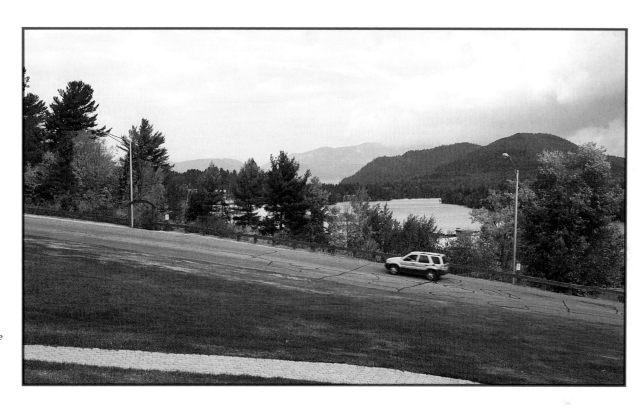

LAKE PLACID
AND MIRROR LAKE
from Grand View House
1889

When Stoddard visited Lake Placid in the 1880s, it was a sleepy rural community. A smattering of homes, stores, and churches rimmed the western shore of Mirror Lake, where today's Olympic village thrives. Large hotels including the Grand View House, Stevens House, Allen House, and the Hotel Rouisseaumont were perched on denuded hills. Seneca Ray climbed the hills for eagle-eye perspectives.

I enlisted Griz Caudle to help me find and photograph Stoddard's Lake Placid vistas. Neither of us knew which old hotel had been where, but we had Seneca Ray's pictures. On the drive to the village, Griz sat in the passenger seat poring over the photos. Like piecing together a jigsaw puzzle, once he established the location of one hotel based on current topography, he could infer the direction to another. In a different image, he could confirm the location of the second hotel and triangulate to yet another. In this manner, and with mounting excitement, he eventually honed in on the locations of all the major hotels.

Deciphering their positions turned out to be easier than rephotographing them; buildings, private property, and maturing vegetation hindered or completely thwarted our attempts. For instance, Stoddard could see both Mirror Lake and Lake Placid from the Grand View House, because the hilly peninsula dividing the two lakes was stripped of trees. The Crown Plaza now occupies the Grand View's footprint. From there, I could readily align Mirror Lake and the mountain ridges in Stoddard's scene, but Lake Placid is now completely blocked from view by tree growth.

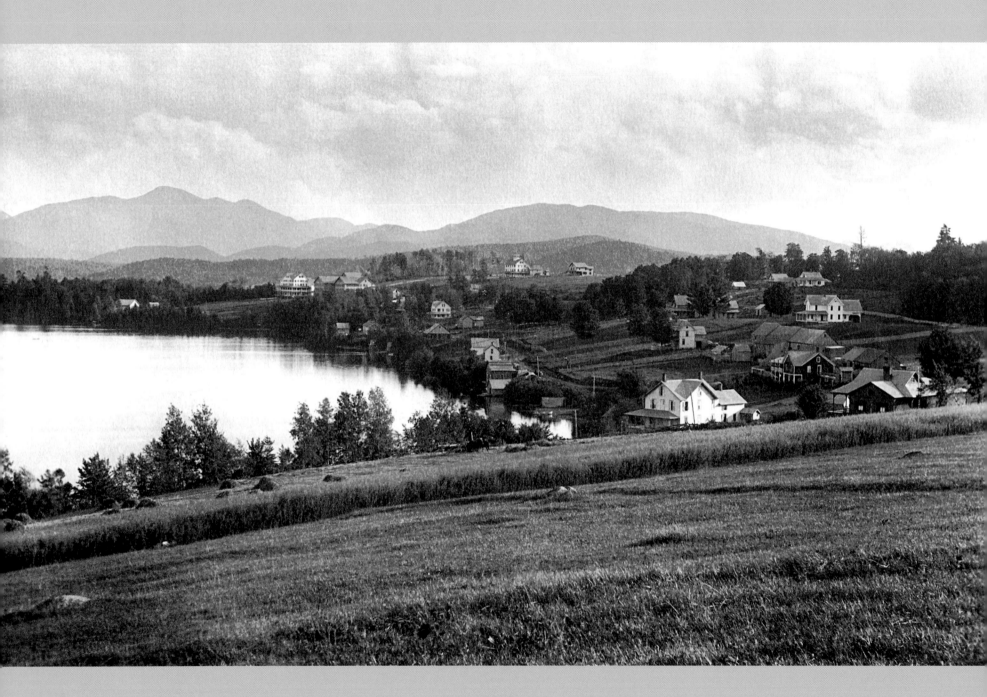

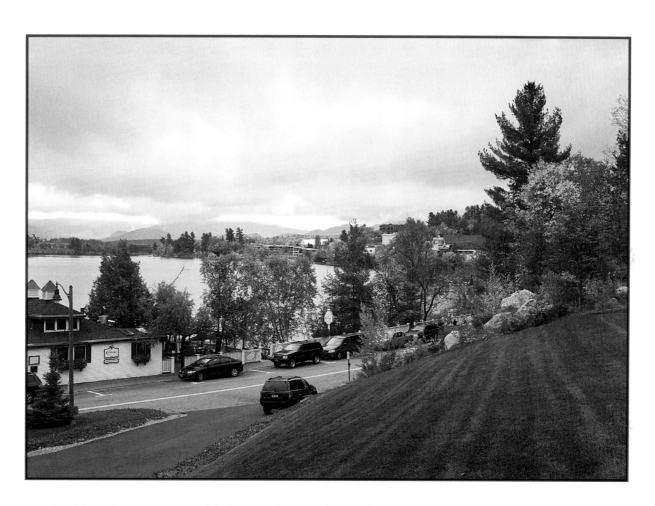

VILLAGE OF
LAKE PLACID
from Stevens House
ca. 1880

Restricted by private property and lush vegetative growth, I could only approximate Stoddard's position for this village view. Whereas he shot from the grounds of the Stevens House, which crowned the peninsula dividing Mirror Lake and Lake Placid, I photographed from the Mirror Lake Inn, downhill and left of his position. His foreground buildings lie near today's busy north end of town, where the Route 86 hill descends to Main Street. The Hilton Lake Placid Resort Hotel is hidden by trees in my image.

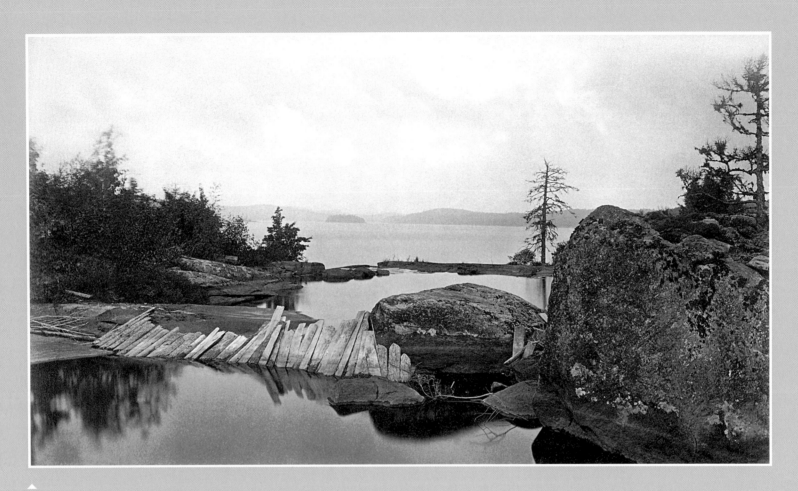

TUPPER LAKE
from Bog River Falls
ca. 1880

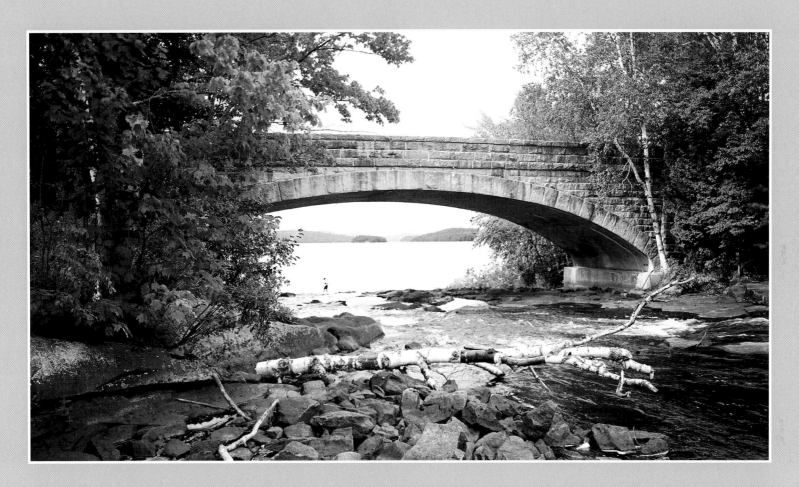

Stoddard photographed an improvised wooden dam or footbridge across Bog River Falls as it descends into Tupper Lake. A stone arch bridge now spans the river. This is a popular spot for painters and a put-in for paddlers heading upstream to Hitchins Pond and Lows Lake.

We both photographed this scene from a rock outcrop in the river.

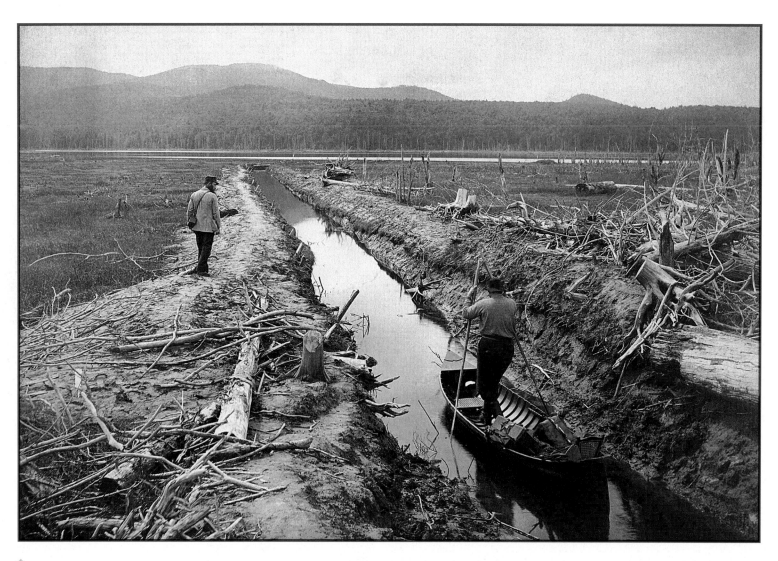

SIMON'S POND
Raquette River
1888

In Stoddard's era, lumbermen hand-dug a diversionary canal a few hundred yards long to float logs from the Raquette River into what is now called Lake Simon, bypassing meanders downstream.

The canal still exists today. It has widened and is lined with overgrown bushes and is still navigable. I photographed Tupper Lake historian Bill Frenette poling into the canal in his guideboat. Mount Morris rises in the background.

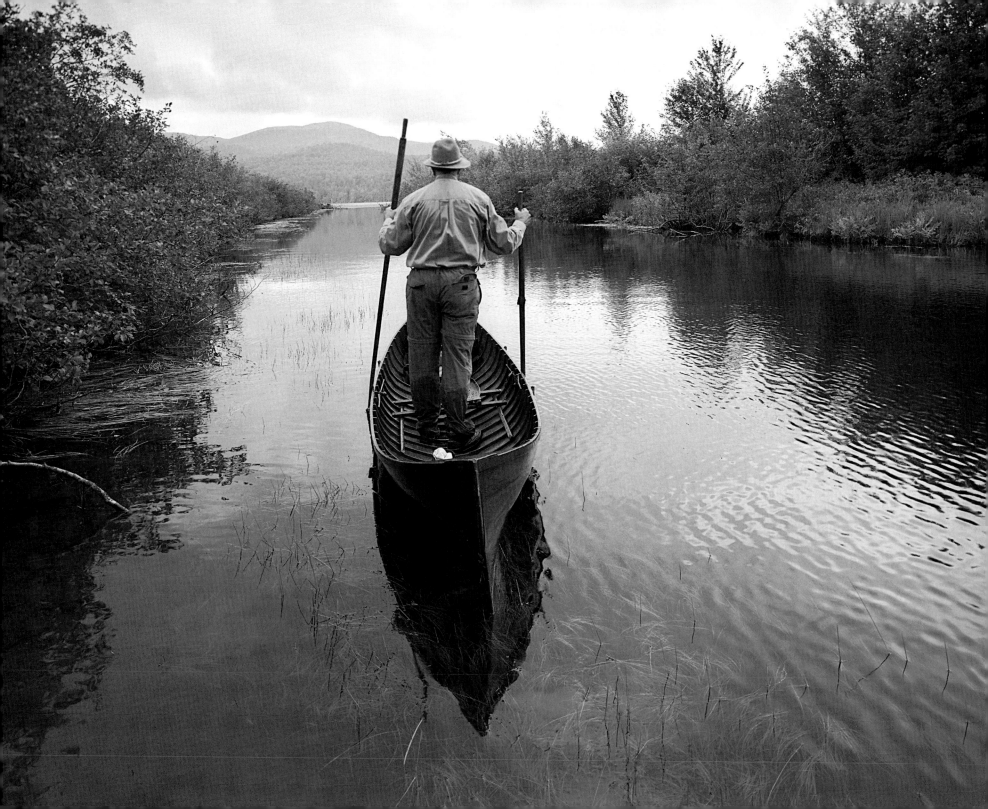

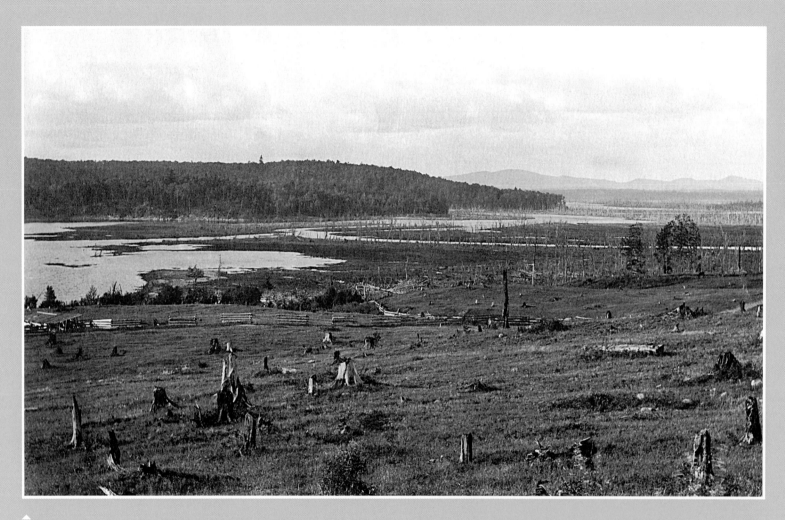

DROWNED LANDS
Tupper Lake Outlet
ca. 1880

In the nineteenth century, the harvesting of the Adirondacks' natural resources—timber, minerals, water power—went virtually unchecked. The forests were vast, the thousands of miles of waterways seemingly an unending source of energy. Like the adventurer and writer, George Washington Sears, who was distraught over the drowned trees he encountered along the Fulton Chain of Lakes, Seneca Ray Stoddard saw first hand the degradation of watersheds caused by rampant logging. At Tupper Lake and elsewhere, he photographed drowned lands, where rising waters from damming by loggers left many acres of rotting and dead trees. He lobbied to change the practices. In 1891, he gave a pivotal lantern slide presentation before the New York State Legislature, urging protection of the watersheds through establishment of the Adirondack Park.

In Stoddard's image, we see the Raquette River as it flows from the east into a depleted Tupper Lake and turns north. The channel persists in the lake today, delineated by navigational buoys. Setting Pole Dam moderates the water level. Anglers prize the lake; the submerged stumps provide excellent habitat for bass. Eagles fish here as well. Their numbers declined when pesticides used in the 1950s and 1960s weakened their eggs, but years after use of the substances was banned, the eagle population is rebounding.

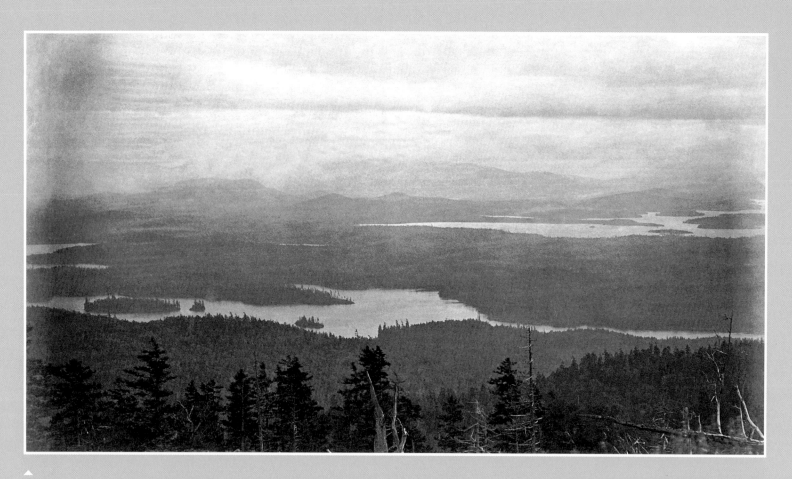

VIEW FROM
ST. REGIS MOUNTAIN
Upper Saranac Lake
ca. 1880

The tremendous water views from the summit of St. Regis Mountain have changed little since Stoddard's day. The summit was more open when he reached it, likely cleared by fires, whether natural or man-made. Surveyors seeking unobstructed lines of sight cleared many Adirondack peaks.

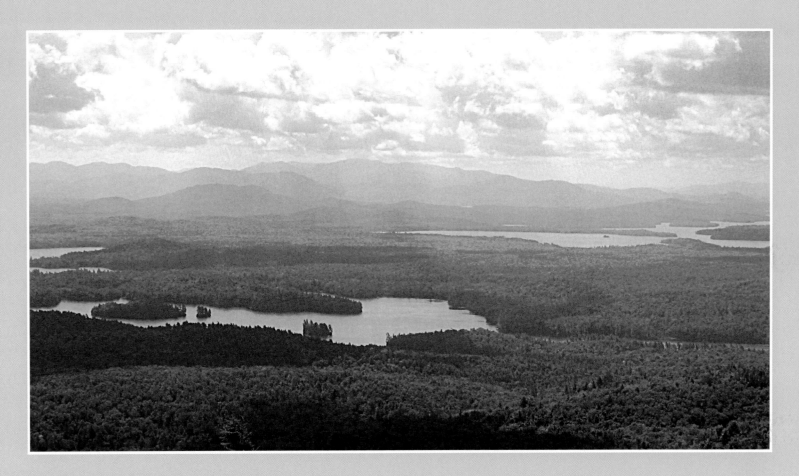

A fire tower was erected in 1918. Spotters manned it until 1990; it is now closed. Vegetative growth has filtered the views to some extent, though there are still stunning panoramic vistas south and east. The mountain overlooks the St. Regis Canoe Wilderness, which encompasses fifty-eight lakes and ponds, with hundreds of miles of wild shoreline. In both of our images, parts of Little Clear Pond are visible at the far left. Island-studded St. Regis Pond is in the center foreground; the St. Regis River flows out of it. Upper Saranac Lake sprawls in the distant right.

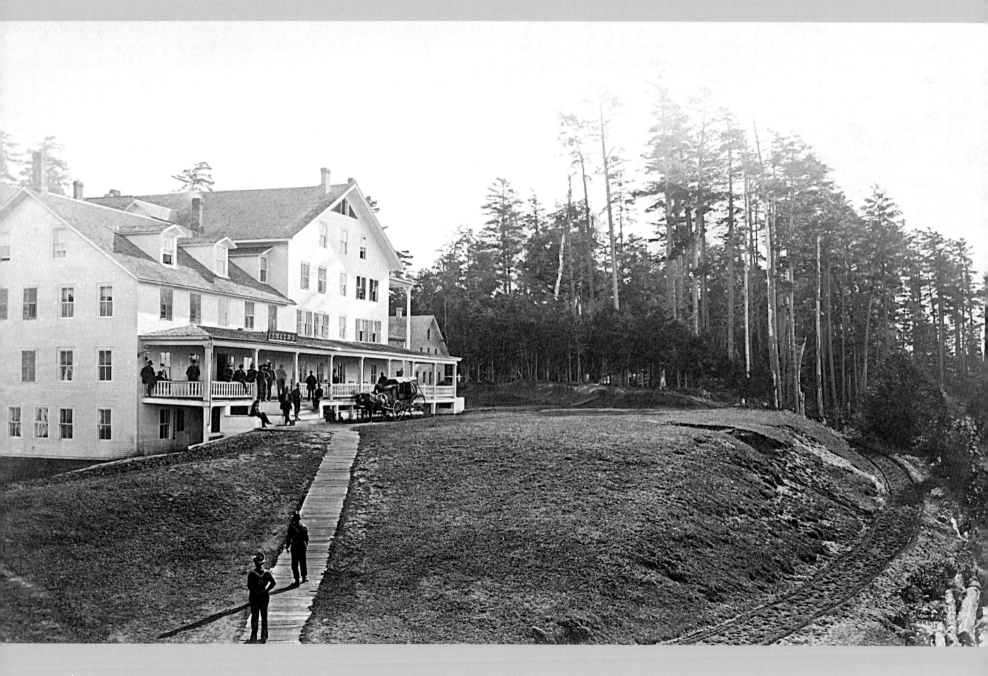

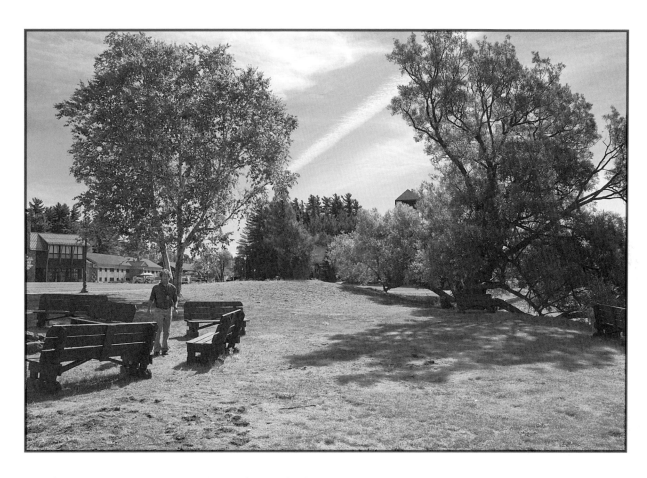

PAUL SMITH'S
St. Regis Lake
ca. 1880

Paul Smith's Hotel opened its doors in 1859. It was perched on a rise overlooking Lower St. Regis Lake, about a dozen miles northwest of Saranac Lake Village. Run by the indomitable Apollos A. (Paul) Smith and his wife, Lydia, it became one of the most fashionable Adirondack hotels. Originally with seventeen rooms, it was expanded several times, eventually to 255 rooms. A large boathouse had quarters for sixty guides. Many guests became so enamored with the area they built Great Camps with elaborate boathouses on nearby Upper St. Regis and Spitfire Lakes, on land purchased from Smith.

The hotel operated until 1930, when it was destroyed by fire. Paul Smith's College, specializing in forestry, hotel management, and culinary curricula, was established on the grounds in 1946. It has undergone major renovations in recent years; Adirondack-style log and stone architecture was chosen to blend aesthetically with the landscape. The Joan Weill Student Center, whose tower can be seen in the back right of my image, opened in 2006. It overhangs the lakeshore, occupying part of the hotel's footprint. The hotel extended into what today is a lawn between the Student Center and the magnificent new Joan Weill Adirondack Library, a corner of which is visible at far left.

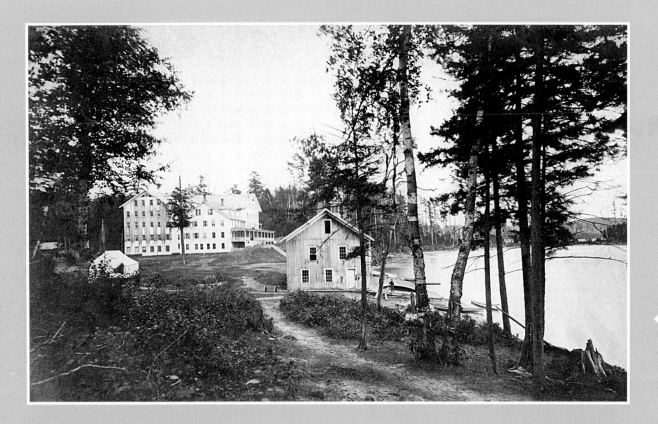

Clues to the college's Victorian past can still be found. The dirt path that led north from the hotel, past the boathouse to some lakeside cottages, is now lined with paving stones. Some of the cottages still stand, out of view behind our position. There have been two different boathouses. The first, pictured here, was destroyed when the lake level rose. A second was built in its place, later moved along the shore, and demolished in favor of a third, which, by happenstance, was never built. A retaining wall surrounded the boathouse in Stoddard's view. It now protects against shoreline erosion.

When I visited the campus, tents had been erected for guests attending a conference on water quality. Likely, Stoddard would have appreciated their concern.

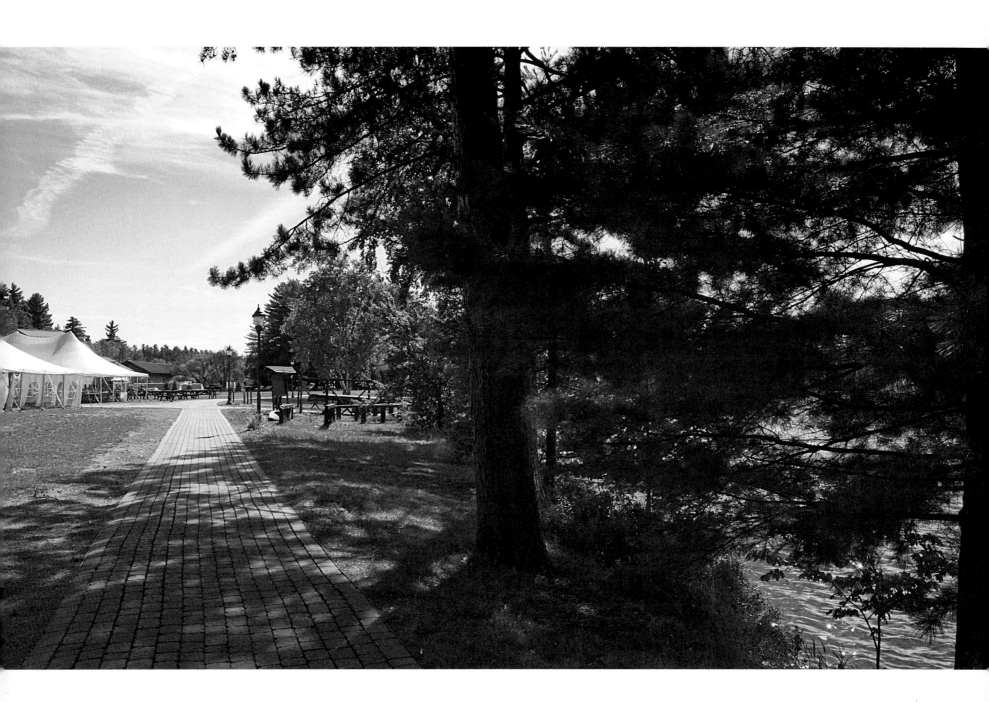

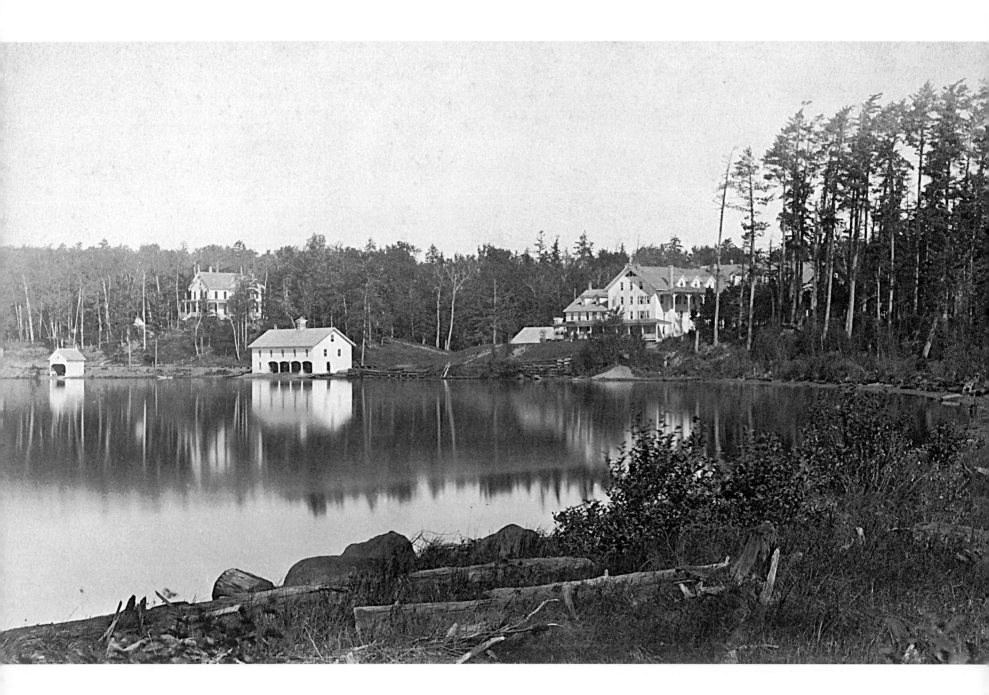

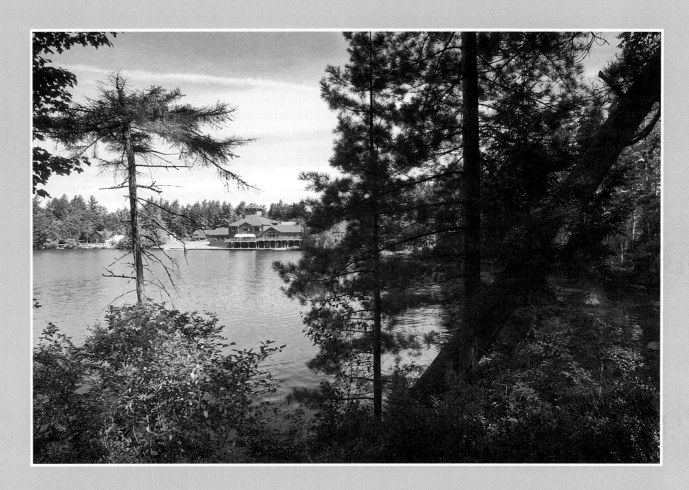

PAUL SMITH'S
St. Regis Lake
ca. 1880

Aligning Stoddard's view of the hotel and boathouse from what is now called Picnic Point proved deceptively difficult. I made some exposures but wasn't confident with my positioning. I later learned that fill had been brought in after Stoddard's visit to anchor the foot of the peninsula and adjacent shoreline. Also, the tall white pines Stoddard saw were not the same I saw; they had been cut. I was forced to re-create my re-creation.

The sprawling Student Center, built on the site of the old Cubley Library, actually sits forward and slightly right of the hotel's position.

Notes on the Imagery

All of the Seneca Ray Stoddard photographs in this book were digitally reproduced from original prints in the collection of the Chapman Historical Museum. To highlight Stoddard's subject matter and artistry, they have been optimized to remove spots, stains, and discoloration and to redress fading resulting from improper initial processing, aging, and damage over time.

The Stoddard Collections

Seneca Ray Stoddard's photographs in this book are but a sampling of the more than three thousand images contained in the S.R. Stoddard Collection of the Chapman Historical Museum. In addition to original prints, negatives, and glass slides, the collection also includes manuscripts, paintings, drawings, maps, and annotated editions of his annual guidebooks. The collection is available to researchers by arrangement.

To order reproductions of Seneca Ray Stoddard images contact:

Chapman Historical Museum
348 Glen Street
Glens Falls, New York 12801
(518) 793-2826
www.chapmanmuseum.org

The other significant collection of Seneca Ray Stoddard's original works is housed in the Adirondack Museum in Blue Mountain Lake. Like the Chapman Historical Museum, the Adirondack Museum archives thousands of prints, original negatives, brochures, books, and other pieces, and welcomes inquiries for review and research.

Adirondack Museum
P.O. Box 99
Blue Mountain Lake, New York 12812
(518) 352-7311
www.adkmuseum.org

Acknowledgements

The genesis for this book was a feature in the December 2002 issue of *Adirondack Life* magazine, for which I rephotographed several Stoddard views. I thank the staff for their support and kind permission to reprint certain passages. I expanded upon that project for a 2005 exhibit at the Chapman Historical Museum.

I've relied heavily on the knowledge and generosity of others to ascertain the locations of long-gone subjects, gain access to private property, and learn the history of the region. I thank Mike Prescott and Rick Rosen for helping me re-create Stoddard photo locations in the Blue Mountain Lake-Raquette Lake region. Mike's historical insights were invaluable. Bill Frenette guided me around Stoddard sites in the Tupper and Saranac Lakes region, and Griz and Deborah Caudle accompanied me to the Ausable Lakes and around Lake Placid. Mike Bresette guided me through Ausable Chasm. I also thank my sister, Ellie Bowie, and Tim Caudle, Jim Frenette, Pete Hornbeck, and Chris Jerome for accompanying me in the field. I thank Elizabeth Folwell, Tom Warrington, and Robert Curry for providing historical information on the Blue Mountain Lake area.

I'm obliged to these individuals and companies who kindly granted me access to their properties: Peter and Suzanne Hoffman of Glen Street Associates; General Manager Darrin Crippen and attorney Tim Clark, representing the Ausable Club; Ausable Chasm General Manager, Jim Bresett; Manager Cathie Cusaick and the Mirror Lake Inn Resort and Spa; the Crown Plaza, Lake Placid; Scott and Alice Patchett of Trout House Village; John and Linda Baker; Rob and Christin Pedlow; Tim Record and the Hudson River Scenic Railroad; Ernie LaPrairie of The Steamboat Landing; manager Carol Doherty and owners Ann and Julius Oestriecher of the Prospect Point Cottages; the Adirondack Museum; Curt Stiles; Joan Mahoney; Paul Smith's College and its Director of Educational Resources, Neil Surprenant.

My enduring gratitude goes to my grandfather, Richard Dean, and father, Everett Bowie, for their technical support.

Special thanks to Rob Igoe, Jr, and Zach Steffen of North Country Books, and Tim Weidner and the Chapman Museum for undertaking this project, and for their dedication to producing this compelling retrospective. I'm indebted to the Chapman for providing the reproductions of Stoddard's images and access to their archives. Thanks also to Tim Weidner for his insightful chapter on Stoddard.

Finally, my love to my wife, Rushelle. Her enthusiastic support and editorial critique much enhanced this book.

—Mark Bowie

I first encountered S.R. Stoddard's photography in 1986 when I was a graduate student in Cooperstown, New York. Since then I have discovered much by studying his images and writings, but I feel it fitting and proper to acknowledge those who have contributed to Stoddard scholarship over the years. Maitland DeSormo is largely responsible for rediscovering Stoddard and rekindling public interest in his photography. Joe Cutshall King, former director of the Chapman, realized the importance of Stoddard's work and was instrumental in securing the collection for the museum. Jeanne Winston Adler, in *Early Days in the Adirondacks*, identified nineteenth century cultural influences on Stoddard as an artist, and Jeffrey L. Horrell, in *Seneca Ray Stoddard: Transforming the Adirondack Wilderness in Text and Image*, examined how Stoddard as a photographer and a writer influenced, and was influenced by, changing environmental attitudes of his time. Most recently, Jane McIntosh, who researched and wrote the script for WMHT's documentary, *Seneca Ray Stoddard: An American Original*, portrayed Stoddard as a unique and talented individual who made a lasting mark on the Adirondack region.

—Timothy Weidner

Published by:

North Country Books, Inc.
220 Lafayette Street
Utica, New York 13502
(315) 735-4877
www.northcountrybooks.com

Chapman Historical Museum
348 Glen Street
Glens Falls, New York 12801
(518) 793-2826
www.chapmanmuseum.org

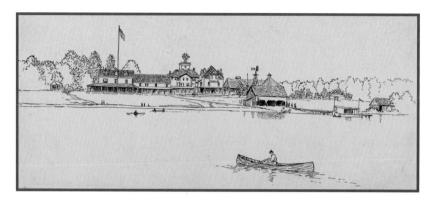

Pen & ink sketch, Prospect House, Saranac Lake, S. R. Stoddard, ca. 1890

Library of Congress Cataloging-in-Publication Data

Bowie, Mark.
 In Stoddard's footsteps : the Adirondacks then & now : featuring the
photography of Seneca Ray Stoddard & Mark Bowie / text by Mark Bowie
& Timothy Weidner.
 p. cm.

 Includes bibliographical references.
 ISBN 978-1-59531-024-8 (alk. paper)
 ISBN 978-1-59531-022-4 (pbk. : alk. paper)

 1. Adirondack Mountains (N.Y.)--History--Pictorial works. 2.
Adirondack Mountains (N.Y.)--Pictorial works. 3. Landscape--New York
(State)--Adirondack Mountains--Pictorial works. 4. Landscape photogra-
phy--New York (State)--Adirondack Mountains. 5. Stoddard, Seneca Ray,
1844-1917--Travel--New York (State)--Adirondack Mountains. 6. Bowie,
Mark--Travel--New York (State)--Adirondack Mountains. 7. Repeat pho-
tography--New York (State)--Adirondack Mountains. 8. Adirondack
Mountains (N.Y.)--Description and travel. I. Stoddard, Seneca Ray, 1844-
1917. II. Weidner, Timothy. III. Title.

 F127.A2B66 2008
 974.7'5--dc22

 2008011690